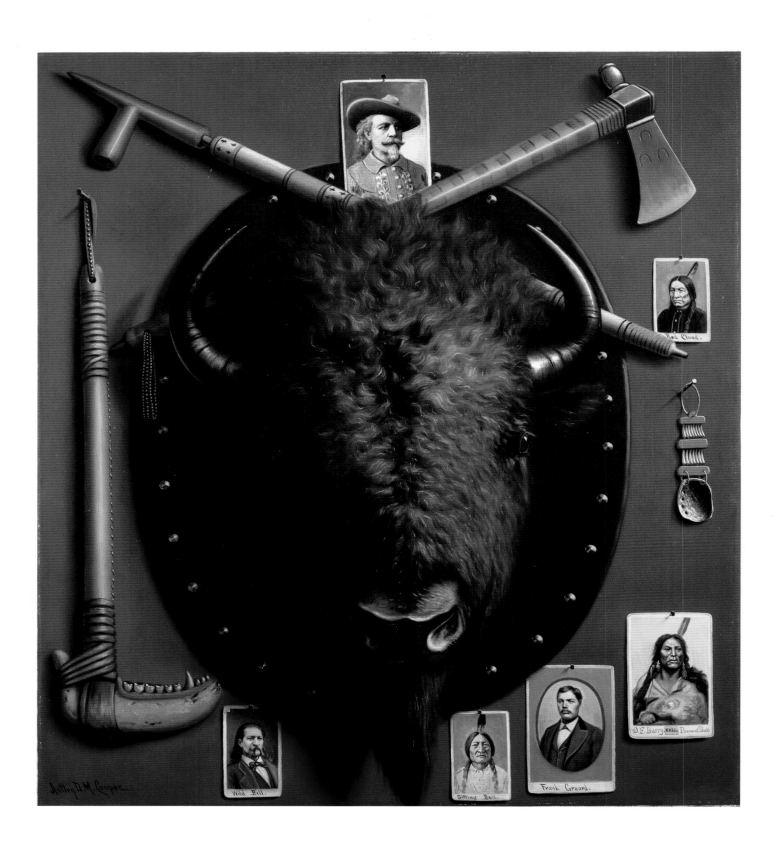

WESTERN PASSAGES

Redrawing Boundaries

PERSPECTIVES ON WESTERN AMERICAN ART

INSTITUTE OF WESTERN AMERICAN ART

DENVER ART MUSEUM

IN ASSOCIATION WITH THE UNIVERSITY OF WASHINGTON PRESS

SEATTLE AND LONDON

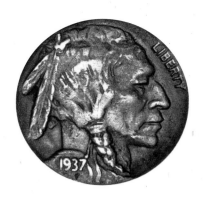

PUBLICATION OF *Redrawing Boundaries: Perspectives on Western American Art*

HAS BEEN MADE POSSIBLE THROUGH THE GENEROSITY OF

RAYMOND AND SALLY DUNCAN

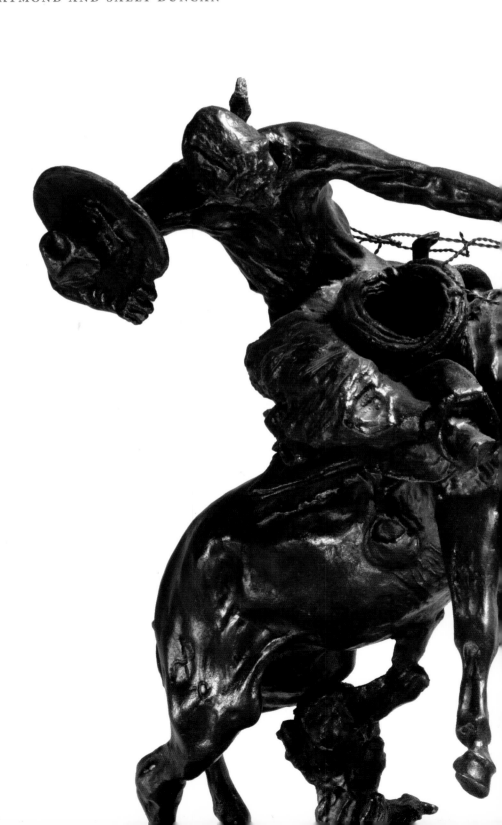

THE INSTITUTE OF WESTERN AMERICAN ART

DENVER ART MUSEUM

100 WEST 14TH AVENUE PARKWAY

DENVER, COLORADO 80204-2788

WESTERN PASSAGES

Western Passages is an ongoing series of books
published by the Institute of Western American
Art, Denver Art Museum, in association with the
University of Washington Press, Seattle and London.

LCN 2006935563

ISBN 10: 0-914738-55-0

ISBN 13: 978-914738-55-0

EDITING Laura Caruso

DESIGN AND PRODUCTION Carol Haralson

*Dimensions of images are given in inches,
height preceding width.*

Printed in Korea

ILLUSTRATIONS: p. 1: Eliot Porter, *Davis Gulch
Escalante River Near Glen Canyon, Utah* (see page 63);
p. 2: A. D. M. Cooper, *Relics of the Past* (see page 78);
above: James Earle Fraser, *Buffalo Nickel* (see page 41);
right: Charles Marion Russell, *The Bronc Twister*
(see page 70).

Contents

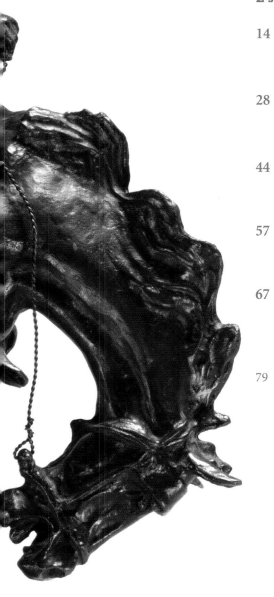

In the six years that have passed since its founding in 2001, the Institute of Western American Art has taken on an air of maturity and begun to establish a place for itself in the museum and art historical community. Under the original direction of Joan Carpenter Troccoli, the institute published two volumes in the series *Western Passages* and organized corresponding exhibitions: *West Point/Points West*, which featured the unique perspectives and collection of Tom Petrie; and *Sweet on the West*, a celebration of the magnificent collection of art donated to the Denver Art Museum by Dorothy and William Harmsen Sr. In addition, the museum was proud to be a venue for *Frederic Remington: The Color of Night*, a group of stunning nocturnes by the West's master painter that was assembled by Nancy Anderson at the National Gallery of Art.

As the institute embarks on the course that I have set as its new director, we plan to continue these laudable efforts and build on previous successes. The first move in that direction is the production of this publication. In these pages we attempt to explore western art's stature as an academic discipline and its place within the corpus of American art historical thought. For providing a broad array of perspectives, we are grateful to our distinguished authors: Brian Dippie, Erika Doss, Patty Limerick, Angela Miller, Martha Sandweiss, and William Truettner. They have offered thoughtful and stimulating assessments of what the art of the West is and has been, why it matters, and how it might be most propitiously studied and viewed. These essays will be presented as lectures at a symposium in the spring of 2007 that is a collaboration between the institute, the Denver Public Library's Western History/Genealogy Department, and the University of Colorado at Boulder's Center of the American West. We are grateful to our partners for their help in planning and presenting the symposium. Special thanks go to James Kroll at the library and Patty Limerick of the Center of the American West.

In the dramatic Frederic C. Hamilton Building, the institute boasts a beautiful new home: the Dietler Gallery of Western Art, named after its primary benefactors, Cortlandt and Martha Dietler. Cort Dietler is also on the institute's advisory board along with his worthy associates Tom Petrie, Jim Wallace, Pat Grant, Henry Roath, and Ray Duncan. Collectively, they have encouraged us to move forward with an ambitious program of publications, symposia, and exhibitions. Ray and Sally Duncan, in particular, have been helpful in seeing this current project to fruition. Through their profound and timely generosity, they have underwritten the cost of this publication as well as the accompanying symposium.

From the start, the institute has enjoyed the enthusiastic support of the museum's leadership. The Denver Art Museum's director, Lewis Sharp, has nurtured and encouraged our efforts over many years. Our deputy director for collections and programs, Timothy Standring, and our chief curator, Margaret Young-Sánchez, have provided critical assistance and counsel along the way. The institute's staff—Joan Carpenter Troccoli, Ann S. Daley, Mindy Besaw, Nicole Parks, and Rebeka Ceravolo—have supplied the collaborative energy to achieve a standard of excellence that befits the stature of the museum and its supporters. The photographic, collections and exhibitions departments have provided essential support, with valued assistance from Jeff Wells, Kevin Hester, Christine Jackson, Roiann Baird, Carole Lee Vowell in Rights and Reproductions and Christie Kirsch, Juhl Wojahn, John Lupe, Art Bernal, and David Gresheimer on our Collections and Exhibitions Management team. My thanks go out to all of them, as well as to Carol Haralson, who, with her masterful design and production skills, has crafted the essays and images into this handsome volume; Laura Caruso for her astute editing; and the many museums, artists, and individuals who have allowed us to enhance these musings with images of art they have either created or own.

GEORGE CATLIN

Né-hee-ó-ee-wóo-tis, Wolf on the Hill,

Chief of the Tribe, detail, 1832

Oil on canvas, 29 x 24

Smithsonian American Art Museum,

Gift of Mrs. Joseph Harrison Jr.

PETER H. HASSRICK

Director, Institute of Western American Art, Denver Art Museum

Where's the Art *in Western Art?*

PETER H. HASSRICK

Thirty years ago, back in 1977, I published a book venerating the high points of nineteenth- and early-twentieth-century painting and sculpture of the American West. Titled *The Way West: Art of Frontier America*, it strove to define what western art was and why it mattered. My conclusion, not particularly surprising, found the genre to be fundamentally one of figurative art with a narrative approach that explored and celebrated themes related to the West—its people, places, and history. Being an art historian by training, I was drawn not so much to inquire about the genre's regional parameters or its historical associations as I was to question its aesthetic foundations. Perhaps phrased another way, I wanted to consider "Where is the *art* in western art?" —an inquiry borne out of frustration with the notion, advanced from the 1940s on, that western art was essentially an analogue to history and, as such, would of necessity follow the prescribed requisites of historical investigation and pedagogy. On the academic side, western art, to be deemed relevant, was forced to conform to methods of historical inquiry and to be accurate and authentic, while within the popular spectrum it was required to reinforce contemporary public notions about the frontier mythos of the taming of the wilderness and winning of the West. Scholarship in the field has traditionally languished somewhere within these two extremes, unable to satisfy either expectation and losing any connection with its aesthetic core in the process.

Western art has thus been diminished on two counts—it is rarely considered for its aesthetic merits and is incapable of fulfilling its obligations as mistress to history. In terms of the delimiting nature of its geography, it has suffered as well. The West, due to regional biases that have pushed it outside the mainstream of American commerce, population, and thought, has been marginalized. For the most part, eastern academics, critics, and museum curators have, whether out of arrogance, provincialism, or lack of understanding, given blanket invalidation to its art. In some instances, as with Charles Russell, western artists have exercised an equal measure of reverse provincialism, debunking eastern artistic traditions as potential spoilers of inborn regional creative genius.

Trends in modern art also conspired to dismiss the merits of western art with its patent and largely nonmodernist penchant for narrative and representation. Thematically, given its anecdotal and historical predilections, western art has been beckoned to serve ideological fads, from post–World War II and Cold War nationalism (as was, oddly enough, abstract expressionism as well) to more recent Marxist and Lacanian revisionism. Moreover, since it has been essentially representational in style, western art has never found a place in the inexorable, linear sweep of art from figuration to abstraction that took place in the 1950s and 1960s. It was dismissed almost overnight as being mere illustration and omitted from

the larger art historical canon, which defined itself as a theoretical continuum and led most everyone to believe that abstraction was the ideal zenith of all art.

Institutionally, with but a few exceptions, western art has been associated with the oft-maligned subculture of the cowboy artists. This has diminished it, fairly or not, to "lowbrow" status, a genre hectored by critics and academics alike as rather more kitsch than *kunst* and dismissed by at least one waggish reporter as "backward-looking and largely beside the point."

One thing appeared to be missing from the critical discourse along the way. Up until the mid-twentieth century, most of the painters and sculptors of the West positioned themselves firmly and consciously within existing artistic traditions of their day. It was within those traditions that they made their most salient aesthetic contributions. Theirs were *au courant* artistic expressions, tailored to contemporary audiences and tastes, that reflected national and, more often than not, international trends. Thus, Alfred Jacob Miller was an extension of early-nineteenth-century French romantic history painting as practiced by Horace Vernet and Eugène Delacroix. Albert Bierstadt was a proclaimed exponent of the Düsseldorf school's dramatic, histrionic style of landscape painting, while Thomas Moran served as an American extension of the English mode exemplified in the art and writings of J. M. W. Turner and John Ruskin. And Frederic Remington, though self-proclaimed as "home grown" in inspiration, was a devout student of French artists—first with military painters like Edouard Détaille and Jean Meissonier and later with the impressionists, especially Claude Monet.

Even so, most artists of the West were seen publicly more as memorialists to a passing scene or era than as creative personalities exploring American themes through current aesthetic dictates. An example would be Alexander Phimister Proctor who, after years of studying sculpture in Paris and New York, produced his bronze *Buffalo Hunt*. The critics ignored the delectation of its Beaux Arts grace, discussing it only as the work of a historian bent on depicting a scene that had recently passed into history.

Nonetheless, there are some revealing counterpoints to all this. Western art, with its figurative core, was not alone in being sacked by the onslaught of abstract expressionism. Regionalism suffered too along the way, and figuration has had, in the ensuing years, several moments of reascendance. Western art was also not simply representational. Art for art's sake practitioners like John Henry Twachtman, John Marin, and B. J. O. Nordfeldt savored the West as a place to paint. And in terms of western art's service to history, the reevaluation of its cultural, political, and social underpinnings and the semiotic redimensioning of long-established works in search of metaphorical subtexts (as discussed in some of the following essays) have been vastly revealing and refreshing. The field has been the beneficiary of considerable contemporary art-historical thought. Scholarship has taken quantum leaps

ALEXANDER PHIMISTER PROCTOR
Buffalo Hunt, 1917
Bronze, 27.5 x 10 x 17.5
Courtesy of the A. Phimister Proctor Museum
with thanks to Sandy Church and Sally Church

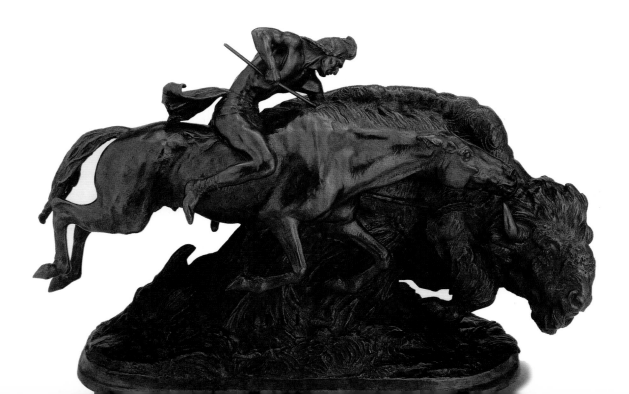

forward in the past twenty years, thanks in large part to a number of major American museums, many of them in the West. The effort has been at least partially effective in helping to integrate western art into the mainstream of American art.

In this volume, the authors have carefully considered many of the issues outlined here. Bill Truettner discusses the problematic integration question, Brian Dippie assesses the discipline's abortive critical aspirations, and Erika Doss inquires into western art's ambivalent connection with popular culture, while Angela Miller and Martha Sandweiss tie western art and photography to the national identity and a prevailing iconic nostalgia. A formalist art history that deals with aesthetic as well as social, psychological, and political context is emerging with refreshing new vigor and attendant cultural weight.

Western American Art

Celebrating the Burden of Popularity

PATTY LIMERICK

In March of 1991, curators, scholars, journalists, and politicians joined together to stage a demonstration of western art's paired and exactly equal powers: first, to inspire and uplift human souls; and second, to provoke arguments, fights, contests, squabbles, and a general melee of intellectual mud-wrestling.

It was a remarkable spectacle to watch, and I was fortunate to play a bit part in the drama. The Smithsonian Institution's Museum of American Art had opened an exhibition called *The West as America: Reinterpreting Images of the Frontier, 1820–1920*. Minutes into the opening reception, the controversy had ignited, as the peevish and irritated seized the opportunity provided by the visitor comment book to express their disapproval—and sometimes their support—of the exhibition's interpretative approach.

I arrived the next day to give a speech at the exhibition's launching conference. For fifteen years, I have been reproaching myself for not having had the sense to fly in the day before, in time to attend this memorable reception. How fascinating it must have been to see the librarian of Congress and his wife in a fully documented dudgeon, storming away from the appetizers and snacks to record their outrage on the first page of the comment book! What a testimony to the power of the written word it must have been to see opposing sides struggle for possession of the pen attached to that comment book!

Things had calmed down a bit the next day when the scholars assembled. But then the fever soon picked up again, as a few members of Congress took up their cudgels to defend the romantic image of the West from the demythologizing assault of the exhibition's curators. Threatening punitive measures to the Smithsonian budget, a couple of senators got matters really stirred up, and as a result I received an enormously flattering phone call. The director of the Museum of American Art asked me to come defend the Smithsonian at a forum. I said I didn't think I had time to make the trip. She said (this is the one and only time that anyone has ever said this to me), "Your nation needs you."

I went to Washington and defended the Smithsonian.

My nation needed me.

Of my various strategies of defense, the soundest one seemed to be that *The West as America* had stirred up controversy by declaring the really quite self-evident truth that western paintings and sculpture, for all their beauty and appeal, rarely addressed and faced up to the injury, cruelty, and brutality that the conquest of the West wreaked upon Indian and Mexican people, nor did they reckon with the disruption and disturbance of natural environments. A comparable display of representations of the South would have shown handsome and engaging paintings and drawings of plantations and then reminded viewers that despite the charm of these paintings, slavery was a brutal and exploitative system.

This, to the great majority of Americans in 1991, would have seemed an entirely obvious commentary, very unlikely to trigger an agitated campaign to defend slavery and plantations from debunking and demythologizing. But the art and history of the American West had landed in a very different world of emotion and sentiment. Question the glory, promise, and mythic power of the American West, and you asked for controversy and a polarized comment book.

The controversy over *The West as America* was not put to rest by my stalwart defense. In truth, it has never entirely ended, and every once in a while, the disturbing outcome seems to be this: the uproar in 1991 may have frightened some museums from taking up a subject matter so sensitive and volatile.

And yet, fifteen years later, looking back at the whole storm, I find myself celebrating one piece of extremely good news: people believe that western American art is worth a fight.

The worst way to position art in a society is to marginalize it, to set it apart from our passions, convictions, and drives and to make viewing it into a matter of inconsequential leisure. When experiencing art is purely and solely an occasion of tranquility, comfort, and peace, the artists, their talents, and their labors have, in my judgment, been treated with a degree of disrespect and disregard.

So western American art has an enviable problem: it is too accessible, too enjoyable, too popular, and, sometimes, too beautiful.

Of all of life's burdens, this should be an easy one to bear. But the qualities of accessibility, enjoyment, popularity, and beauty position western American art on a battlefield, since people know enough—well, really, more to the point, *feel* enough—about the art to get very angry indeed over its interpretation.

While this may not make life as a critic or historian of western art very comfortable, it certainly makes it interesting and consequential. Thus, this collection of essays is not "just about art": on the contrary, by writing about representations of the American West, these authors have ventured into some of the most important, and some of the most heated, issues of both the past and of our time. In a way that will always catch us by surprise, a direct nerve connects the status of western American art to national and personal self-esteem. Since this is a seemingly unchangeable condition, we may as well learn to celebrate it and even to take advantage of it.

Back in March of 1991, I sat at the launching conference for *The West as America* and listened as one of the curators talked about Frederic Remington. Part of his talk set forth Remington's efforts to secure his own elite status as well as his unsavory attitudes toward minorities and immigrants. And while this expert talked, we in the audience gazed at a big screen on which slides of Remington's paintings appeared. When the presentation was over, I had a good understanding of the fact that I would not much have cared for Remington's company or conversation. *But* I had also become enchanted with the images I had contemplated, and soon after the session I felt genuinely privileged to visit the exhibition and see the works firsthand. On my way back to the hotel, I stopped at the gift shop and bought several boxes of note cards of Remington's work. I wasn't sure if I should feel guilty over having developed a deepened appreciation of Remington's artistic gifts while also developing a deepened discomfort with his racism and elitism.

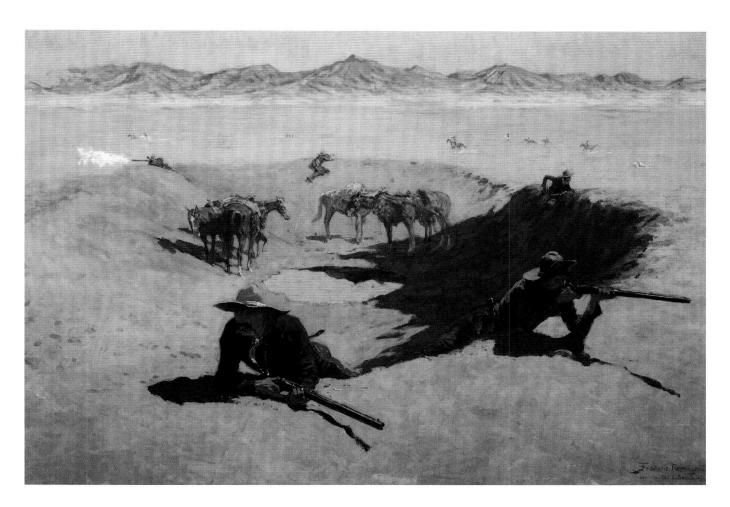

FREDERIC REMINGTON

Fight for the Water Hole, 1903

Oil on canvas, 27.25 x 40.125

Museum of Fine Arts, Houston,

The Hogg Brothers Collection,

Gift of Miss Ima Hogg

I was fortunate, in this moment of deep ambivalence and perplexity, to come across the speaker from earlier in the day. "Now see what you've done," I said. "Your speech made me appreciate Remington's gifts as an artist more than I ever had before. Now I've gone and bought these note cards, and now I will have to send them to people who will think I am endorsing racism and elitism, and I will have to use most of the space on the inside of the note card to explain that I value the art even though some of the artist's attitudes repel me."

"That," said the speaker and the curator, "is exactly what I wanted."

So it is a wonderful and mysterious world, the world of western American art. In this world, we all play our roles, and we play them with vigor. Some of us represent the landscapes, societies, and cultures of the American West in paintings, drawings, and sculpture. Others among us write lectures, articles, books, and museum-wall commentaries to interpret the work of these artists. The rest of us, meanwhile, respond with intensity and strong emotion to both the art and the interpretation, dragging into the terrain every issue of controversy we can lay our hands on: patriotism, faith, foreign policy, racial tension, masculine pride, environmental alarm, and free speech, to name a few of the more frequently deployed.

And, with all of these efforts converging and conflicting, the contemplation of western American art remains a project of enormous vitality. As this collection of essays shows.

In the Enemy's Country

Western Art's Uneasy Status

Brian W. Dippie

One of the iconic Charles M. Russell themes is an Indian party proceeding cautiously through another tribe's territory, alert and vulnerable. *In the Enemy's Country* (1921) is a case in point. First exhibited at Denver's Brown Palace Hotel in late November 1921, the 24-by-36-inch oil painting was mentioned in a *Rocky Mountain News* review as an "impressive" work showing Kootenai Indians slipping strategically into Blackfeet territory. A catalog description elaborated:

> Kootenai Indians crossing the Blackfeet country. There were no buffalo west of the mountains. The Kootenai and other tribes who lived west of the range crossed to hunt buffalo. The Blackfeet were enemies of most of these western tribes, so that they were always in danger while in the buffalo country. That is why they chose dark horses and threw their robes over them with the fur side up and walked at the shoulders of their mounts. At a distance they resembled a small band of buffalo. Old bulls traveled in small bands, and no Indian cared for bull meat. Therefore they were not molested.[1]

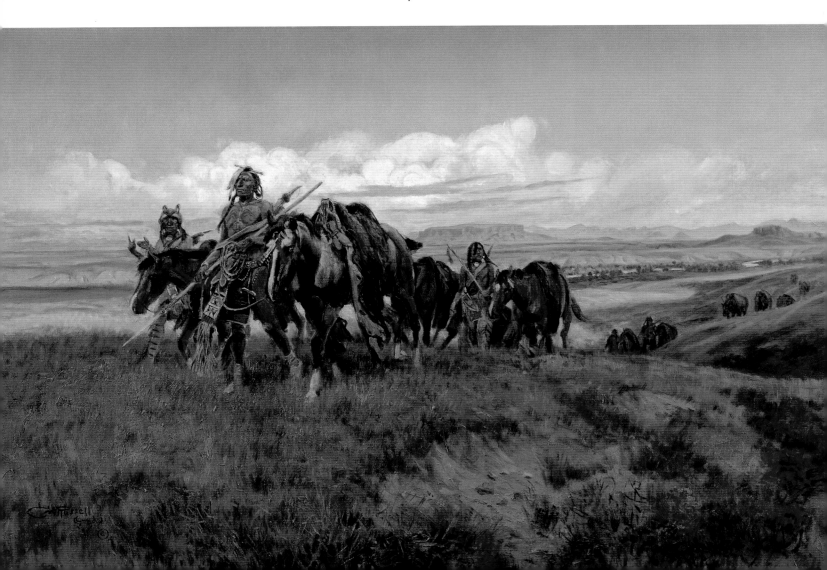

"Always in danger"—or, at least, in fear of attack: that seems an apt metaphor for the uneasy status of traditional western art in American museums at the beginning of the new millennium.

In the Enemy's Country helps explain that uneasiness. It is visually appealing—seductive, even. It features Indians in traditional dress. It shows horses. It is set in an open, spacious land. Unmistakably, it represents the nineteenth-century American West. And it tells a story certified authentic through realistic detail. Verisimilitude—the appearance of truth—is western art's own Code of the West. A documentary imperative rules even when the scene is set before the artist's time, as this one clearly is. Russell's picture may be imaginary, but it draws on personal observation of life in Montana in the 1880s to establish a greater truth, "The West That Has Passed." For his contemporaries, his firsthand knowledge and mastery of facts were key credentials. "It is obvious that this artist knows his west from the ground up, having, as the French say, 'passed that way,'" a New York critic commented in 1912. That judgment had not changed when a California reviewer eleven years later wrote: "Russell's chief claim to the high degree of artistry he has attained lies in his ability to reproduce life, actual and virile, on his canvas. He knows his subject down to the last detail. It is second nature with him."[2]

To judge Russell's work, then, one turns to its content. Are the details correct? Is that beaded pipe bag of Kootenai design? Are the hairstyles authentic, and the body paint and the leggings and the bow and quiver? The narrative elements can also be considered. Are they plausible? Notice the verdant foreground; it is spring or early summer on the plains, and the buffalo will be fat. Thus the Kootenai incursion into Blackfeet country. Notice the spear pointing at the ground, so that no light flashes off its metal tip and betrays the intruders' presence. The need for silence is conveyed by the figure on the left communicating in sign language instead of spoken words. The picture is persuasive. It mirrors reality.

FACING AND DETAILS BELOW:

CHARLES M. RUSSELL

In the Enemy's Country, 1921

Oil on canvas, 40 x 51.5

Denver Art Museum,

Gift of the Magness Family

in memory of Betsy Magness

1. M. R. F. Valle, "Roerich Paintings Arrive, Are Declared Revelation / Famed Painter of Western Scenes Is Found to Be Sculptor of Ability, Picturing Incidents in Plains' Life," *Rocky Mountain News*, December 4, 1921; and *Special Exhibition / Paintings and Bronze by Charles M. Russell / Great Falls, Montana* (Santa Barbara: [School of the Arts, 1923]). *In the Enemy's Country* was subsequently displayed in Los Angeles and Duluth in 1924, in New York (twice) and Washington, D.C., in 1925, and at the first major Russell exhibition after his death in

1926, held in Santa Barbara, where it was described as representing "Shoshone tribesmen, traveling in the Blackfeet country." (*The First Memorial Exhibition of the Works of Charles Marion Russell "Painter of the West"* [Santa Barbara: Art League of Santa Barbara, 1927].) For background, see William E. Farr, "Going to Buffalo: Indian Hunting Migrations across the Rocky Mountains," pts. 1 and 2, *Montana: The Magazine of Western History* 53 (Winter 2003): 2–21; 54 (Spring 2004): 26–43. I commented on "the uneasy current status of western art"

in "The Visual West," in *The Oxford History of the American West*, eds. Clyde A. Milner II, Carol A. O'Connor, and Martha A. Sandweiss (New York: Oxford University Press, 1994), 704; twelve years later, the indicators cited then are more pronounced.

2. *New York Evening Globe*, March 6, 1912; and "Russell, Cowboy Artist, Reflects Virile Genius," *Santa Barbara Morning Press*, January 10, 1923. In 1924 a Los Angeles paper observed: "In the accuracy of detail, the creator has been faithful

to the time and the place of the old frontier." ("Great Painter Here, Tells Art Secret," unidentified clipping, November 1924, Helen E. and Homer E. Britzman Collection, Taylor Museum for Southwestern Studies of the Colorado Springs Fine Arts Center, Colorado Springs [hereafter, Britzman Collection].)

Where, given such an emphasis on subject matter and accuracy, does artistry fit in? Russell was proud to call himself an illustrator. He mocked technical discussions of his craft but worked to enhance his ability at telling stories in paint. *In the Enemy's Country* uses visual evidence effectively to make a narrative point. The line of Indians walking beside their horses trails off until the distant figures actually resemble buffalo, confirming their stratagem's success. The landscape forms an evocative backdrop to the action. A gleaming river, gilded bluffs and buttes, and a purple line of distant mountains speak enticingly to wanderlust, while the approaching Indians, enveloped in shadow as they top the rise, are silhouetted against the sunwashed valley below and Montana's Big Sky above, achieving monumentality. The vibrant colors represent Russell's late-life palette. Reflected light on men and animals is rendered in green and blue; the foreground, green and russet, is splashed with pinks and turquoise; and the creamy white clouds are tinged with yellow, pink, and mauve. The scene is storybook beautiful, the Old West it conjures up a glowing, magic land—"Dreamland Montana," to quote an observant contemporary.[3]

Storybook beautiful, however, might imply a limitation to Russell's art. Was *In the Enemy's Country* simply illustration on a grand scale? Russell's contemporaries noted the high register of his colors and commented on them without downplaying the primacy of subject matter. "Apart from the beauty of the Russell paintings, the beauty of purpling hills and snow-covered buttes, of misty cloud effects against the autumn sky, of amethyst sunset and topaz dawn, his pictures have their distinct historical significance," a Los Angeles reviewer stated in 1924. "In the accuracy of detail, the creator has been faithful to the time and the place of the old frontier." As for his brighter, gaudier colors, it was Russell's conclusion by 1919 that his palette in the past had been too "stout," and he cited as a liberating influence Maxfield Parrish. Apparently he met Parrish and visited his studio. In 1921, he explained his admiration:

> You know this fellow Maxfield Parrish? Well, I think he's the greatest artist in the world. He paints things out, but, oh, the colors! He's got imagination and he sees things clear that other artists only dream about. I've learned a lot from that man.
>
> Lots of people say he paints too vivid. They don't know. Say, did you ever go out in these hills in Montana or New Mexico or Colorado in Indian summer, did you? Well, if you can see color you know there's not fine enough colors in the tubes to exaggerate them.
>
> Lots of people sneer at commercial artists. Well, I do commercial work myself . . . I believe the finest artists in America do commercial work. Parrish himself will do soap advertisements and make masterpieces of them.[4]

So there it was. Russell liked illustration, not modern art. "I don't get this stuff with one man's eye six inches below the other," he remarked. "It don't look good to me." His audience consisted of nature-loving "real men" who knew "whether a saddle is on right or on wrong." "The art fellows," in contrast, knew nothing "about outdoors," so their opinions did not count. A friendly reviewer put a positive spin on things. Russell, he wrote, "is so individual that modern movements in the art world, eddying around him, never touch the big simplicity of his nature." To his critics then and since, however, Russell's unwillingness or inability to see afresh and go beyond surface realism in rendering his themes was a fundamental flaw. He might be right that "regular folks still like story telling pictures," but his art had not advanced. "He draws strongly and on the whole correctly," a New York critic observed, "but his work, especially his painting, is distinctly illustrative in character."[5]

The same judgment dogs western art to this day. As a genre it is considered at best old-fashioned, at worst not art at all. Its reliance on narrative realism has long been deemed suspect. If it is what it seems to be and aspires to nothing more, then it does not merit critical attention. Content to repeat standard motifs with varying degrees of skill, it has made no important contribution to the larger development of American art and has

3. [Arthur Hoeber], "Cowboy Vividly Paints the Passing Life of the Plains," *New York Times Magazine*, March 19, 1911.

4. "Great Painter Here, Tells Art Secret," unidentified clipping [Los Angeles, November 1924], Britzman Collection, Colorado Springs; "Cowboy Artist Paints as He Talks, Lives," *Minneapolis Journal*, December 14, 1919; and "'Just Kinda Natural to Draw Pictures, I Guess,' Says Cowboy Artist in Denver to Exhibit Work," *Rocky Mountain News*, November 27, 1921. Frank M. Chapman Jr., "The Man Behind the Brush," *Country Life* 50 (August 1926): 35, described a 1925 Russell exhibition as "a riot of blue and gold and green and red." See also Brian W. Dippie, *Looking at Russell* (Fort Worth, TX: Amon Carter Museum, 1987), 120–21; and for an insight into Russell's later colors, see Nancy C. Russell to M. Grumbacher Co., July 22, 1923, carbon copy, Britzman Collection, Colorado Springs, ordering three studio tubes each of Indian red, Venetian red, vermilion, burnt sienna, raw sienna, yellow ochre, Payne's grey, and lemon yellow; four each of Vandyke brown, cerulean blue, and cadmium yellow deep; six ultramarine blue and twelve each of rose madder, cobalt blue, and zinc white quadruple size. For an analysis of Parrish's colors and their application, see Mark F. Bockrath, "'Frank Imagination, within a Beautiful Form': The Painting Methods of Maxfield Parrish," in *Maxfield Parrish, 1870–1966*, by Sylvia Yount (New York: Harry N. Abrams, Inc., in association with the Pennsylvania Academy of Fine Arts, Philadelphia, 1999), 122–51.

5. "Cowboy Artist Paints as He Talks, Lives," *Minneapolis Journal*, December 14, 1919; "Paintings of the West," supplement, *El Palacio* 8 (July 1920): 236; "West That Has Passed," *American Art News*, April 1911. For the standard favorable judgment, see "Art and Artists," *Los Angeles Times*, March 27, 1921: "The life of the cowboy and the life of the Indian of Montana—it is around these two fine western subjects that Russell's artistic activities have revolved. He has given us invaluable records, for he knows the truth about both. . . . note the accuracy of the details of the costumes. Russell knows."

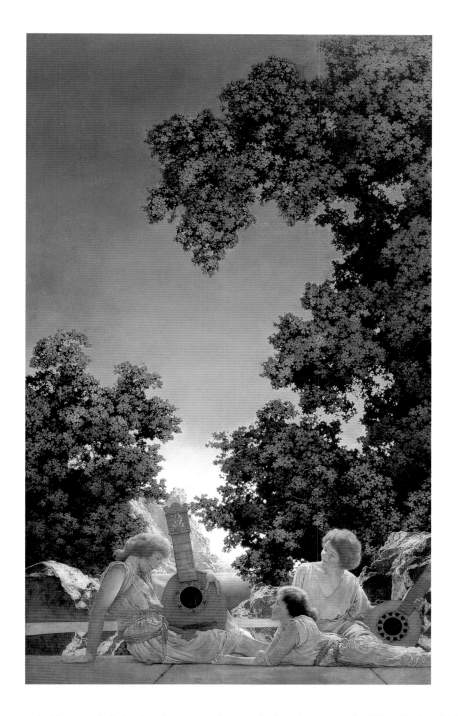

6. All quotes are from Richard Nilsen, writing in the *Arizona Republic.* "Cowboy Art Rides off into Uncertain Future," November 10, 1991; "Cowboy Art Expanding Range, Focus," October 18, 1992; and "A Dose of Poetic Justice for Cowboy Art," October 25, 1992. Nilsen in 2003 was listed as the *Republic*'s "art/theater/movie/video critic." More recent columns would suggest he has moderated his position.

probably retarded the development of more challenging art in the West. Richard Nilsen, writing in the *Arizona Republic* in the early 1990s, scorned "cowboy art" as inimical to "a rising level of art sophistication in Arizona." Even a superior cowboy painting in the annual Cowboy Artists of America exhibition was done "in the style of a business portrait, purposely conservative and out of date." The whole genre could be traced back to Frederic Remington and Russell: "With half a dose of Remington / And Charlie Russell's flavor, / The Cowboy Artists paint clichés / Long out of critics' favor." So much for the tradition enshrined in western art museums. Nilsen's sophisticated Arizonans could have simply ignored art that was antimodernist, that pandered to "mass taste," and that confused detail for truth. But his reference to Cowboy Artists strutting their "white male" status introduced a more ominous note, one that has left western art museums feeling vulnerable and defensive.[6]

About the time the Amon Carter Museum of Western Art became the Amon Carter Museum in the late 1980s, change was afoot. What had debuted in 1961 as a showcase for Amon G. Carter's personal collection of art by Frederic Remington and

Charles Russell by then had evolved into something more—a museum of American art and western photography. Introducing the catalog of her father's Russells in 1966, Ruth Carter Johnson paid tribute to his vision. "It is very understandable," she wrote, that Amon Carter would be attracted to Remington and Russell:

> His taste in art sprang more from an historic sense than from one of mere esthetics. The art of the West was to him a documentation of the history of a people and of a time with which he identified himself. . . . Essentially it was his pioneer spirit—his own courage, determination, and ambition—which conformed with the works of Remington and Russell. He felt very much at home with the characters they depicted, seeing in them the virtues which he admired—honesty, fortitude, and hope, as well as tenacity and "stick-to-itiveness."[7]

The "West" for the Amon Carter Museum of Western Art started out as a place. In its inaugural exhibition catalog, Johnson noted that Fort Worth's newest museum was dedicated to the "education, interest and pleasure of all the citizens of this great area, 'Where the West Begins.'" Twelve years later the Amon Carter's director, Mitch Wilder, drawing on the idea of the frontier as process, advanced a more expansive definition of the West to account for the museum's expanding collection. He offered a "riddle"—"What is western?"—and an answer: "Today we find it tedious to draw boundary lines, for the West of the museum collections reflects the changes of our physical and political history, it is *American*."[8]

Since the West no longer began at Fort Worth, the museum's collection did not either. Consequently, the Amon Carter Museum's shortened name is truer to its present identity: "An American Masterpiece. Filled with American Masterpieces." But the longer original name would have served just as well if indeed the West *was* America. Two decades before the term "New Western History" came into vogue, the Amon Carter Museum of Western Art had published monographs on Hispanic folk art, contemporary American Indian art, and women artists and photographers (Georgia O'Keeffe, Clara McDonald Williamson, Dorothea Lange). Its list of titles encompassed a modernist who found inspiration in the mythic West, Walt Kuhn, and an assortment of twentieth-century West Coast artists. This eclectic mixture, with Remington and Russell thrown in, seems prescient.

7. Ruth Carter Johnson, foreword to *Charles M. Russell: Paintings, Drawings and Sculpture in the Amon G. Carter Collection—A Descriptive Catalogue*, by Frederic G. Renner (Austin: University of Texas Press, 1966), v. Johnson concluded with a vision of the museum's collection growing and perhaps evolving, always in the name of excellence. By the time the companion catalog combining Amon Carter's and Sid Richardson's Remingtons was published in 1973, the sixties had left a marked impression on Ruth Carter Johnson. Her foreword now explicitly linked her father's passion for Remington to "the pioneer spirit of the American West, its disciplines, and the inherent quality of freedom and opportunity taken in proper perspective and reasoned

orderliness." Ruth Carter Johnson, foreword to *Frederic Remington: Paintings, Drawings, and Sculpture in the Amon Carter Museum and the Sid W. Richardson Foundation Collections*, by Peter H. Hassrick (New York: Harry N. Abrams, Inc., 1973), 8.

8. Ruth Carter Johnson, preface to *Inaugural Exhibition: Selected Works / Frederic Remington and Charles Marion Russell* (Fort Worth, TX: Amon Carter Museum of Western Art, 1961); and Mitchell A. Wilder, preface to *Catalogue of the Collection, 1972* (Fort Worth, TX: Amon Carter Museum of Western Art, 1973), 1.

9. William H. Truettner, ed., *The West as America: Reinterpreting

Images of the Frontier, 1820–1920* (Washington, DC: Smithsonian Institution Press for the National Museum of American Art, 1991).

10. David M. Lisi, review of *Frederic Remington: The Masterworks*, by Michael Edward Shapiro and Peter Hassrick, *Art and Auction* 10 (June 1988): 114.

11. C. R. Smith, introduction to *Inaugural Exhibition* (see n. 8); and Ray Merlock, preface to *Hollywood's West: The American Frontier in Film, Television, and History*, eds. Peter C. Rollins and John E. O'Connor (Lexington: University Press of Kentucky, 2005), xi. What the Amon Carter Museum began on its own accord, other museums continued under some duress as revisionist

western history tightened the noose around "old western history." The Rockwell Museum of Western Art in Corning, New York, founded in 1976, kept its name but "reinvented" itself in 1998 to become more inclusive, while the Gene Autry Western Heritage Museum, founded in 1988, has evolved into the Museum of the American West within the Autry National Center, whose mission is to explore "the experiences and perceptions of the diverse peoples of the American West, connecting the past with the present to inform our shared future." The National Cowboy Hall of Fame and Museum, which opened its doors in Oklahoma City in 1965 to pay "tribute to the cowboy," has evolved into the National Cowboy and Western Heritage Museum,

THOMAS MORAN
Indian Retreat, 1896
Oil on canvas, 30.5 x 12.5
Denver Art Museum, William Sr.
and Dorothy Harmsen Collection

With no "tedious" boundaries confining it, the Amon Carter in short order had become the leader in western art scholarship—a position it has never relinquished. The field seemed to glow with promise. But hopes that western art would at last take its place as American art were dashed when the National Museum of American Art's 1991 exhibition *The West as America* attached so many negative connotations to the theme that museums with substantial collections of traditional western art could only duck and run in search of higher ground.[9]

One must bear in mind that western art as a genre had never received such prominent exposure before. Now it was shoved onto the national stage to epitomize every bad tendency in America's past. The exhibition was a debut and a swan song for western art, in line with academic trends in western history, but it did not meet a welcoming reception. After all, western art was outsider art—"considered a sort of idiot-cousin" of American art, "exiled to the dusty attic," as one reviewer memorably observed about the time New York critics were gearing up to pummel an exhibition of Remington masterworks at the Metropolitan Museum of Art in 1989.[10] Western art tends to be judged collectively, as a genre. The shared qualities that unite it under a single museum's roof in the first place—subject matter and treatment—expose it to blanket judgment. Hating cowboy hats is itself old hat, however. Only close attention allows a viewer to appreciate difference where similarity is obvious, and close attention is a quality absent in many critical evaluations of western art and individual western artists. Consequently, western art's loyal audience, long inured to disdain and dismissal, was unresponsive to *The West as America.* Eastern institutions had rarely paid attention to it before, having never liked it. What could be important about their not liking it now?

The exhibition caused a mighty stir—then seemed to pass, leaving the East-West divide in western art undisturbed. In fact, it had a lasting impact, pricking cultural insecurities in the western museum world. In introducing the Amon Carter's inaugural exhibition catalog back in 1961, C. R. Smith had written that Carter "understood" paintings by Russell and Remington "because their subject was the frontier and their story was about the courage of the pioneer, about the men and women who had curiosity about what was on the other side of the horizon." *The West as America* had exposed such sentiments as triumphalist and had used the art enshrined in western museums as evidence for the indictment. How could these museums avoid self-doubt? Were their prized paintings and bronzes—like western movies at the end of the twentieth century—simply embarrassing relics "manifesting (indeed, perhaps even celebrating) destructive and damaging tendencies and practices of American culture?" Were western art museums repositories not only of bad art but of bad values?[11]

This self-doubt comes at a time when western art's popularity with the public, judging from prices paid by avid collectors, is secure. The Coeur d'Alene Auction in Reno this year realized sales totaling over $27 million. The upward trend has been consistent. In 2001 a watercolor by Russell at the same auction set a record for *any* American watercolor at auction when it sold for $2.3 million, and last year an oil painting by Russell brought

whose collections span "the history, grandeur, and complex cultures of the American West." (Charles P. Schroeder, foreword to *A Western Legacy: The National Cowboy and Western Heritage Museum* [Norman: University of Oklahoma Press, 2005], vii.) Fair enough—after all that prototypical "Cowboy Art," Charles M. Russell evolved into a painter of the American Indian—though one wonders if

"National Cowboy" will always be part of the museum's name. Shortening a name is nothing new: Tulsa's Gilcrease Museum was once the Thomas Gilcrease Institute of American History and Art and Calgary's Glenbow Museum ("Where the World Meets the West") was the Glenbow-Alberta Institute. Such name changes are innocuous (the word "Institute" must be too musty-sounding), but

"reinventing" a western art museum is another matter. Advertising for the C. M. Russell Museum in Great Falls used to rest its case on Russell's art, urging tourists to "Visit the C. M. Russell Museum in Great Falls for an unforgettable experience in Western art and history." Brochures featured typical examples of his work. Today, his classic subject matter is downplayed in advertising to stress instead a

family-friendly experience at "The Russell," while the 2006 edition of a slick travel publication promoting "Montana's Russell Country" does not reproduce a single example of the artist's work. Where are Russell's cowboys and Indians?

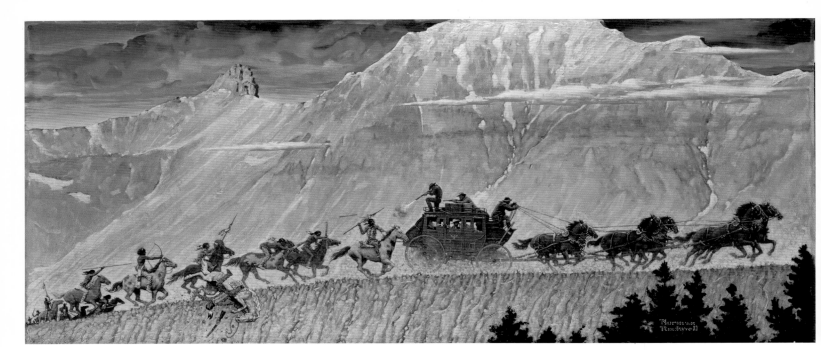

NORMAN ROCKWELL
The Stagecoach, ca. 1966
Oil on wooden panel, 47.25 x 19.25
Denver Art Museum, Gift of Richard
and Sue Williams. Printed by
permission of the Norman Rockwell
Family Agency. Copyright ©1966
The Norman Rockwell Family Entities.

$5.6 million. Dollar figures may be a crass measurement of art's value, but the art market has always been about commerce, and no museum is too high-minded to take notice. That said, the escalating prices realized in Reno impress some critics much more than the art. A *Wall Street Journal* writer greeted news of the Russell watercolor's sale with the observation that western art "has long been sneered at as 'cowboy art' by the art-world elite, and many collectors would rather sit on a cattle prod than hang a rodeo scene over the mantel." However, a Russell painting is harder to ignore with seven figures trailing behind it. "The art-world elite" may not care, but western art's continuing popularity in the real world is incontestable.[12]

Popularity is only one consideration when it comes to art—but it is not, as some critics would have it, an entirely negligible one. In the 1950s, when the *Saturday Evening Post* was the gold standard in general interest magazines, its weekly covers offered a procession of images shedding a flattering light on American life. Before he established himself as one of the most popular of western artists, John Clymer painted bird's-eye views of homegrown scenery to entrance *Post* readers, while Norman Rockwell, for his legion of admirers, was the twentieth century's greatest genre painter as he served up slices of American pie spiced with insights into the human comedy. The public applauded him as their own folksy genius long before the critics "discovered" him in the catalog of a major 1999 retrospective. "I guess I am a storyteller," Rockwell had observed in 1946, "and although this may not be the highest form of art it is what I love to do." He saw himself starting out at the tail end of the "golden age" of illustration and cited among his inspirations the work of Frederic Remington. "Every artist has his own peculiar way of looking at life," he explained. "The view of life I communicate in my pictures excludes the sordid and ugly. I paint life as I would like it to be." Remington, in turn, had done the same, Rockwell said, ignoring the "drab" to concentrate on the romantic and exciting—"cowboys sitting around a

12. Brooks Barnes, "Koch Purchase Boosts Western Art," *Wall Street Journal,* September 7, 2001.

13. Jack Alexander, biographical introduction to *Norman Rockwell: Illustrator,* by Arthur L. Guptill (New York: Ballantine Books, 1976; New York: Watson-Guptill, 1946), xxi; Norman Rockwell, as told to Thomas Rockwell, *Norman Rockwell: My Adventures as an Illustrator* (Indianapolis, IN: Curtis Publishing Company, 1979), 24; and see Maureen Hart Hennessey, Anne Knutson, et al., *Norman Rockwell: Pictures for the American People* (Atlanta, GA: High Museum of Art, with the Norman Rockwell Museum, Stockbridge, MA, in association with Harry N. Abrams, New York, 1999), the catalog of a major traveling exhibition. Rockwell's *The Stagecoach* illustrated the poster for the 1966 remake of John Ford's classic 1939 western *Stagecoach.*

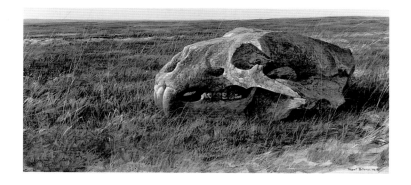

ROBERT BATEMAN

Polar Bear Skull, 1991

Acrylic on board, 13.6 x 29.625

Denver Art Museum, Funds from
Contemporary Realism Group

FREDERIC REMINGTON

Downing the Nigh Leader, 1907

Oil on canvas, 50 x 30

Private Collection

campfire, an attack on a stagecoach." Fittingly, when it came time to paint his own version of an Indian attack on a stagecoach, Rockwell adopted Remington's "peculiar way of looking at life" but added his own perspective. *The Stagecoach* (1966) is thus as unmistakably Rockwell as *Downing the Nigh Leader* (1907) is Remington. And it is utterly faithful to the storytelling tradition of representational art in which both were nurtured.[13]

After World War II, artists like Rockwell were dismissed as hacks by critics enthralled with abstract art. Since Rockwell, like Russell, wore his illustrator label proudly, he worked on unperturbed, basking in the public's adulation and enjoying a popularity that has not diminished with his death in 1978. But to this day critical disdain still marginalizes artists who favor a realistic mode of representation. Two Canadian examples can make the point. Robert Bateman, a British Columbian who is one of the world's most popular wildlife painters, accepts as he approaches eighty years of age that he will never be acknowledged by the "hoity toity art world" even though his conservationist vision is thoroughly up to date and his brand of realism—like that of Andrew Wyeth, he has said—was arrived at after youthful experimentation with abstraction. Public art museums in Canada might be desperate to boost attendance and funding, but they would never compromise their standards by hosting a Bateman exhibition even if, as his dealer states, a ten-day showing of twenty-four originals at a local gallery attracted seventeen thousand people. Len Gibbs, a painter hailing from Alberta with cowboy subjects in his realist repertoire, has accepted rejection by the art establishment philosophically, relishing the fact that museums that will

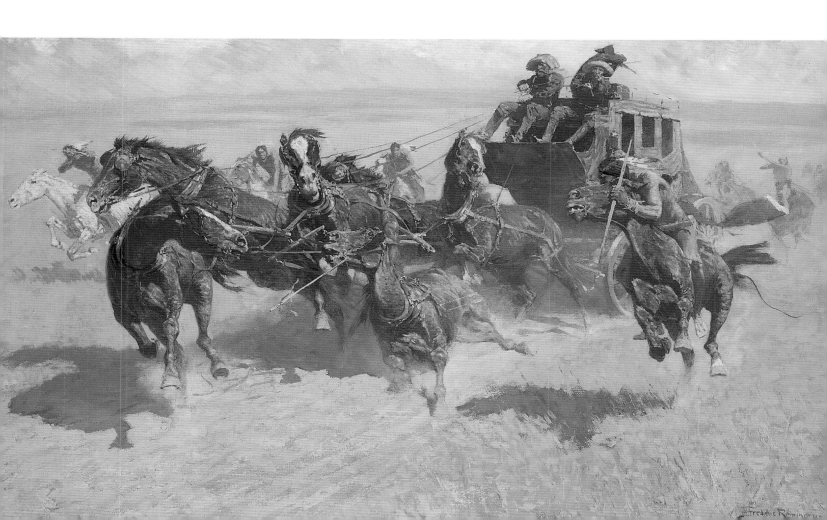

not display his work are happy to ask him to donate paintings to fundraisers. The public likes, and buys, his work—just as the public has always patronized representational artists whose paintings speak to them directly, requiring no interpreters.[14]

The people versus the elite is an old story in American cultural history, of course, and one hardly limited to western art. But western art often serves as a lightning rod for the storms generated by the clash, perhaps because the disconnect between its popular and critical reputation is so pronounced. Consigning western art to dusty attics on artistic grounds has always been easy, since admirers and detractors alike agree that western art places content before aesthetic considerations. If the book collector's mantra is "Condition, condition, condition," and the realtor's "Location, location, location," western art's is "Subject, subject, subject"—with the added understanding that the subject must be rendered accurately.[15]

George Catlin, who stands near the head of the line in any historical survey of western art, was recognized for his initiative in forming a gallery of Indian paintings in the 1830s, but remained under a cloud of suspicion that he was an imaginative tourist who improved upon reality for romantic effect. Fidelity to truth was the issue when well-placed contemporaries charged him with flights of fancy and singled out his paintings—today considered crown jewels in his Indian Gallery—showing the Mandan O-kee-pa ritual. Lacking was much comment on his artistry. A waspish acquaintance, who considered Catlin "utterly incompetent" as a portraitist, in 1834 mocked his choice of subjects, noting a dearth of critics "among the Black Hawks and the White Eagles . . . to ruffle his mind." Catlin's defense of his artistic deficiencies rested on the nature of his enterprise. Indians, like the wilderness they inhabited, were fast disappearing. His work would be an invaluable record in paint, and thus speed took precedence over artistic refinement. This strategy invited comment on his subject matter, not his execution. Only Charles Baudelaire—whose poetry would be attacked for its objectionable content—was fully responsive to Catlin's artistry, particularly his use of color: "Red, the colour of blood, the colour of life," and "Green (the colour of Nature, calm, gay and smiling)—singing their melodic antiphon." Others were content to judge Catlin's Indian portraits at face value.[16]

Attacks on Catlin's truthfulness were attacks on his work because western art permits no critical distance between them. This was Remington's dilemma when, late in his career, he wanted writers to focus on his art, not him. But the criteria for judging an art supposedly grounded in personal experience would not separate the two, and Remington's knowledge of the West continued to dominate assessments of his artistry. One might

FACING PAGE:
GEORGE CATLIN
The Cutting Scene, Mandan O-kee-pa Ceremony, 1832
Oil on canvas, 22.875 x 27.5
Denver Art Museum, William Sr. and Dorothy Harmsen Collection

14. Carolyn Heiman, "Royal Roads Gets Bateman Art," *Victoria (BC) Times Colonist,* June 23, 2006; Jim Gibson, "The Last Picture Show," *Times Colonist,* March 11, 2001; and see Brian Hutchinson, "Bateman's Gift to Canada: Hero in U.S. Not as Revered at Home," *National Post,* June 23, 2006; and Robert Amos, "Robert Bateman, Naturally," *Times Colonist,* June 13, 2004. In Robert Hughes, *American Visions: The Epic History of Art in America* (New York: Alfred A. Knopf, 1997), 506–10, Rockwell's representational style is introduced as a foil for modern art. An essential (I use the word deliberately) rebuttal is Tom Wolfe, *The Painted Word* (New York: Farrar, Straus and Giroux, 1975), which first appeared in *Harper's,* April 1975, 57, with the subheading: "What you see is what they say." Wildlife art represents another western-tinged representational genre—indeed, most of the western artists, including Russell and Remington, contributed to it, and the National Museum of Wildlife Art is located in Jackson, Wyoming. A major Robert Bateman painting is a star attraction.

15. However tempting, it would be simplistic to say that the cultural clash is between the coasts and the interior, since New England houses museums of representational art in addition to the Norman Rockwell Museum in Stockbridge, Massachusetts, and the taste for realism is international. *American Art Review* serves as a bimonthly vehicle to feed that appetite. Historical western art features prominently in it, while contemporary western art is showcased in *Southwestern Art* and, particularly, *Art of the West,* while *Wildlife Art* reaches outward to subgenres like sporting art and angling art. It is New York City, with its vision of "fly-over country" implicating Los Angeles as well, that best represents highbrow elitism in the battle with popular taste. For skirmishes on other fronts, see, for example, Greil Marcus, *Dead Elvis: A Chronicle of a Cultural Obsession* (New York: Doubleday, 1991), 48–49, 59; and Tad Friend, "Letter from California: Blue-Collar Gold," *New Yorker,* July 10/17, 2006, 74–83. Friend describes "Blue Collar comedy"—defiantly lowbrow and hugely popular—as an expression of resentment toward cultural elites

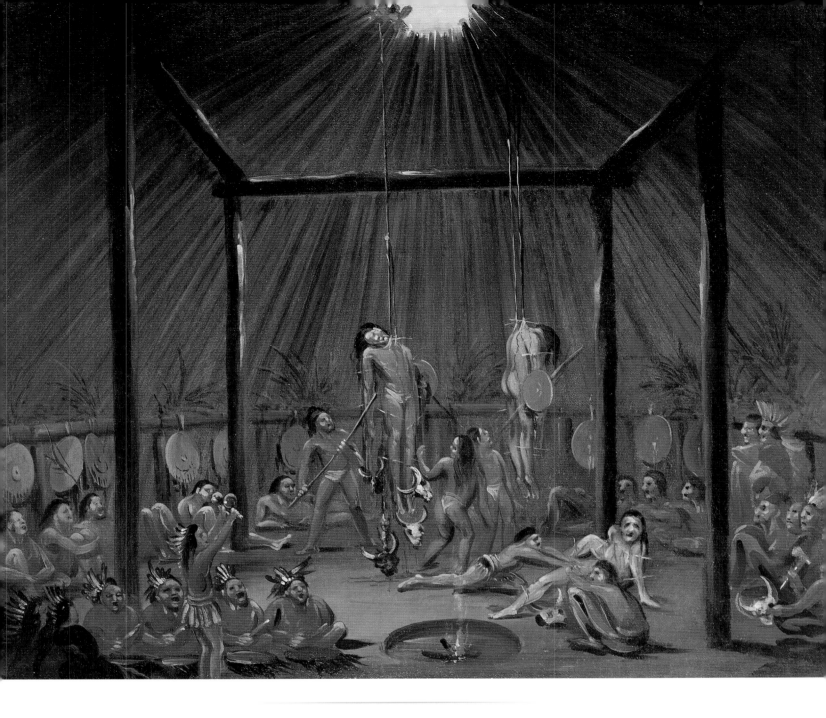

and concludes that its detractors on both coasts "might even have to confront the idea that there are indeed two Americas and that theirs—the isolate island states of Manhattan and Hollywood—is wildly out of step with the rest of the country." Examples could be multiplied indefinitely. One more will do. Mickey Spillane's obituary this year notes that "he considered himself a 'writer' as opposed to an 'author,' defining a writer as someone whose books sell"—a refrain sounded by western novelists back when westerns, like hard-boiled detective stories, were a popular genre. See Associated Press,

"Mike Hammer's Creator Attracted 100 Million Fans," *Victoria (BC) Times Colonist*, July 18, 2006; and, for more on these issues, Brian W. Dippie, "Afterword: Remington Schuyler and the American Illustrative Tradition," in *Remington Schuyler's West: Artistic Visions of Cowboys and Indians*, comps. Henry W. Hamilton and Jean Tyree Hamilton (Pierre: South Dakota State Historical Society Press, 2004), 87–109.

16. William Dunlap, *History of the Rise and Progress of the Arts of Design in the United States* (New York: Benjamin Bloom, 1965; New

York: George P. Scott and Co., 1834), 172; Charles Baudelaire, "The Salon of 1846," in *The Mirror of Art: Critical Studies*, trans. and ed. Jonathan Mayne (Garden City, NY: Doubleday Anchor Books, 1955), 73; and see Brian W. Dippie, "Now I Am George Catlin Again: Exile and Return, 1852–1871," in *Catlin and His Contemporaries: The Politics of Patronage* (Lincoln: University of Nebraska Press, 1990); Nancy K. Anderson, "'Curious Historical Artistic Data': Art History and Western American Art," in *Discovered Lands, Invented Pasts: Transforming Visions of the American West*, by Jules David

Prown et al. (New Haven, CT: Yale University Press for Yale University Art Gallery, 1992), 1–35; and, for a relevant recent case study, Peter H. Hassrick, "William Ranney: A Painter's Requiem to the Mountain Man," *Montana: The Magazine of Western History* 56 (Summer 2006): 42–53.

sympathize with an artist trapped by expectations that he had lived everything he showed, but Remington himself used accuracy as his weapon of choice in attacking a rival artist, Charles Schreyvogel, for aspiring to his title as the West's supreme pictorial historian. The documentary imperative that Remington simultaneously rejected and upheld loomed large in his campaign for recognition as a pure painter, because critics could not forget the role it had played in his success as an illustrator. Some who praised his illustrations for showing the unvarnished truth faulted his paintings for exhibiting the same quality. "There has never been a time when Mr. Remington did not have something to say, but too often it has been more suited to literary statement than to the scope of paints and canvas," a New York critic wrote in 1903. "You can convey the horrors of a starving death on a burning Arizona desert better in words than with a brush, because such a scene is scarcely susceptible of decorative treatment, which is more or less an essential in painting." Some found repose in his night scenes and thought them more successful than the rest of his work in avoiding "the domination of the illustration habit; that is to say, . . . a self-imposed necessity to have his picture tell a story." Remington's more painterly canvases chipped away at this criticism, until he could declare his 1908 exhibition an unqualified success. "It was a triumph," he wrote in his diary. "I have landed among the painters and well up too." As he told a friend, "I am no longer an illustrator."[17]

Remington's obsession with winning over the reviewers has become a celebrated episode in the history of western art, signaling the moment one of its towering figures turned his back on storytelling in paint in exchange for critical acceptance. Ironically, he fooled no one. His exhibition pieces all depicted the "Grand Frontier," as he put it, and

FREDERIC REMINGTON
The Cheyenne, 1901
Bronze, 21 x 24.5 x 7.5
Denver Art Museum, Funds from the
William D. Hewit Charitable Annuity
Trust

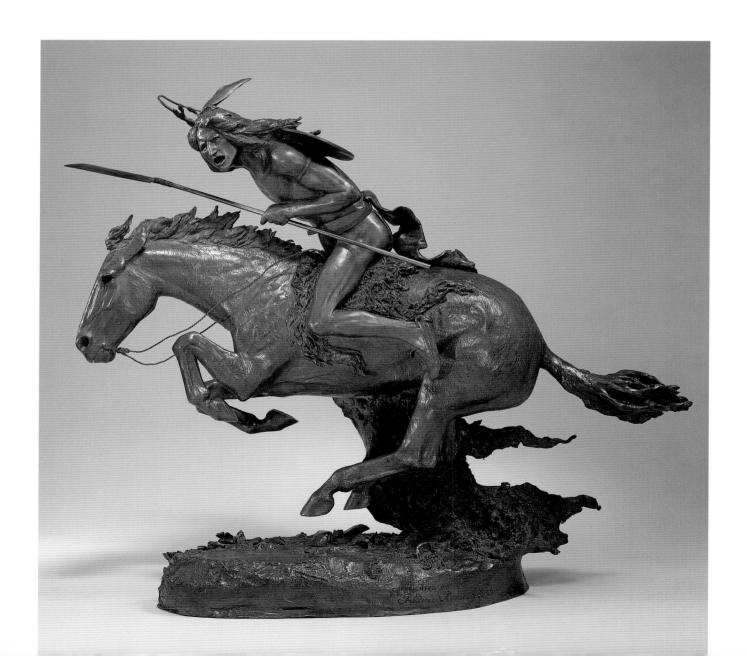

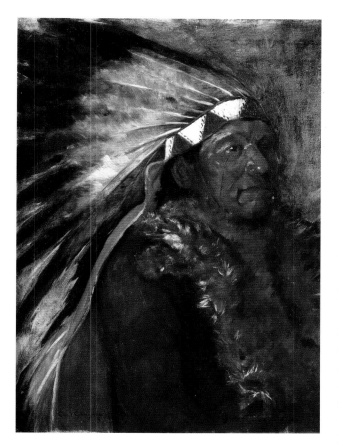

CHARLES SCHREYVOGEL
Sevaro, Chief of Capota Ute, no date
Oil on canvas, 29.5 x 23.25
Denver Art Museum, William Sr. and
Dorothy Harmsen Collection

subject matter still defined them. Certainly the New York critics who took turns berating the Metropolitan's Remington exhibition in 1989 were not deceived. They saw through the mastery "of light and shade and of novel and fascinating color schemes" that had dazzled their predecessors eighty years before to discover nothing new in western art. We must remove our cowboy hats and hold them to our chests as we ponder the *New Yorker*'s judgment on the show: "From the vague and documentary to the laughably impressionistic to the corny and moonlit, Frederick [sic] Remington's paintings of Indians chasing cowboys, his lackluster illustrations for *Harper's*, and his clichéd bronzes of riders on horseback are unworthy of serious attention by a major art museum."[18]

In the end, and for all his crowing, Remington, a New Yorker himself, could not win over "an 'Eastern-centric' art establishment."[19] His western subject matter got in the way. There is a lesson here. Perhaps it is time to stop trying. I approach the issue as an American historian, not an art historian, and shifting tendencies in contemporary western art are outside my purview. But when even a museum like the Buffalo Bill Historical Center in Cody, Wyoming, seems uneasy about the future prospects of its historical western art collection, it may be time to return to first principles. Western art is not an immovable mountain, but it is what it is. Those who want to know it must familiarize themselves with the terrain. Too many have chosen to skirt around it and deliver pronouncements on what they would have found had it been worthy of their effort. Western art museums, sensitive to uninformed dismissals, are left searching for what amounts to respectability. An obvious strategy is to bring in new art, or old art not traditionally considered western. One can surround the old with enough of the new that the message of the old is muted. One can oppose old and new, with the new clearly preferable because it is more in line with contemporary values. In the end, these strategies avoid the issue: What to do with historical art that cannot be bent to modern agendas? Hide it? Critique it, thus disparaging it while continuing to display it? Or accept it as a legitimate artistic expression with emotional and aesthetic appeal? That is, accept it for what it is, just as any art museum anywhere accepts historic art on its own terms?

If the current uneasiness with western art is being driven mainly by western history's present preoccupation with social history, it is important to note that nothing remains static in the academic world. A new revisionist wave—not neo-Turnerian exactly, but more receptive to the power of the frontier myth—may be rolling toward history's shores. New western history is graying, after all, and a younger generation of scholars wants to advance its own concerns. Western history will never again be an exclusive bastion of

17. "Art," *New York Evening Mail*, April 9, 1903; Als Ik Kan [Gustav Stickley], Notes: Reviews, *The Craftsman* 10 (April 1906): 122; Frederic Remington, Diary, December 12, 1908, Frederic Remington Art Museum, Ogdensburg, NY; and Frederic Remington to John Howard, January 21, [1909], in *Frederic Remington—*

Selected Letters, eds. Allen P. Splete and Marilyn D. Splete (New York: Abbeville Press, 1988), 419. For the Schreyvogel affair in 1903, see Brian W. Dippie, *The Frederic Remington Art Museum Collection* (New York: Frederic Remington Art Museum in association with Harry N. Abrams, 2001), 218–21.

18. Frederic Remington, Diary, July 30, 1909, Frederic Remington Art Museum, Ogdensburg, NY; "Mr. Remington's Paintings Shown," unidentified clipping [December 1908], Frederic Remington Art Museum, Ogdensburg, NY; and Goings On about Town, *New Yorker*, March 6, 1989, 14.

19. Betsy Fahlman, professor of art history at Arizona State University, quoted in Richard Nilsen, "Female Western Artists Out to Blaze Own Trail," *Arizona Republic*, March 31, 2006.

white pioneers; diversity is here to stay. That said, the astonishing academic fascination with Buffalo Bill Cody in recent years suggests there is still life in old heroes, that the last drop of significance has yet to be wrung from the topics of the past, and that the Buffalo Bill Historical Center in Cody is right to advertise itself as home to "the legend"—with, let me add, a fine collection of western art supporting that proposition. "Where have all your heroes gone?" the museum's leaflet asks. You need not love Buffalo Bill, but you cannot ignore him. Nor can you ignore the art. "The Louvre may have the Mona Lisa," Dina Mishev comments on Wyoming's state travel website, "but the Whitney [Gallery of Western Art at the Buffalo Bill Historical Center] has the *Last of the Buffalo* by Albert Bierstadt and the giant *Custer's Last Stand* by Edgar S. Paxson, as well as a few thousand other historic and contemporary western pieces." Some of the museum's advertising locates Cody "Where the West begins," which seems fair enough, given that the Amon Carter long since abdicated that distinction for Fort Worth. A little wallowing in Buffalo Bill and his legacy will do western history no harm, and it could do western art a great deal of good.[20]

A critic writing in 1925 about Charles Russell's first and only exhibition in the nation's capital remarked that "a newer kind of Indian and cowboy painting is before the public, revealed in the work of the Taos men and some of those who live on the coast and seldom show their pictures in the wide area between New York and San Francisco. But it is safe to assert that the Remington or Russell kind of Western painting will never lose its following." I have ignored Taos and Santa Fe to concentrate on Russell and Remington because they best represent the contested status of western art today. Southwestern art was appreciated more in its time and since, perhaps as properly "decorative," to recall the New York critic's reservations about Remington's all-too-brutal brand of western realism. It is in the thrust of that turn of phrase—"the Remington or Russell kind of Western painting"—that a history of condescension and dismissal manifests itself. But I have played Cassandra too often where the future of western art is concerned. It is time for a little of that legendary western optimism.[21]

20. Buffalo Bill stars, or at least plays a supporting role, in the following academic books published in the past decade: L. G. Moses, *Wild West Shows and the Images of American Indians, 1883–1933* (Albuquerque: University of New Mexico Press, 1996); Paul Reddin, *Wild West Shows* (Urbana: University of Illinois Press, 1999); Joy S. Kasson, *Buffalo Bill's Wild West: Celebrity, Memory, and Popular History* (New York: Hill and Wang, 2000); Robert W. Rydell and Rob Kroes, *Buffalo Bill in Bologna: The Americanization of the World, 1869–1922* (Chicago: University of Chicago Press, 2005); Louis S. Warren, *Buffalo Bill's America: William Cody and the Wild West Show* (New York: Alfred A. Knopf, 2005); Dan Moos, *Outside America: Race, Ethnicity, and the Role of the American West in National Belonging* (Hanover and Lebanon, NH: Dartmouth College Press and University Press of New England, 2005); and Sam A. Maddra, *Hostiles?: The Lakota Ghost Dance and Buffalo Bill's Wild West* (Norman: University of Oklahoma Press, 2006).

21. Untitled clipping, *St. Louis Daily Globe-Democrat*, April 19, 1925, Britzman Collection, Colorado Springs. For more on some of the themes introduced here, see Brian W. Dippie, "Of Documents and Myths: Richard Kern and Western Art," *New Mexico Historical Review* 61 (April 1986): 147–58; Dippie, "Western Art Don't Get No Respect: A Fifty-Year Perspective," *Montana: The Magazine of Western History* 51 (Winter 2001): 68–71; Dippie, "Drawn to the West," *Western Historical Quarterly* 35 (Spring 2004): 5–26; and Dippie, "'Chop! Chop!': Progress in the Presentation of Western Visual History," *The Historian* 66 (Fall 2004): 491–500. I have more than had my say on the subject.

22. *Special Exhibition of Paintings and Bronzes by Charles M. Russell* (Los Angeles: The Biltmore Salon, 1924); and *The First Memorial Exhibition of the Works of Charles Marion Russell "Painter of the West"* (Santa Barbara: Art League of Santa Barbara, 1927). *Wolf Men* today bears the date 1925, presumably because Russell reworked it after its first exhibitions. "Russell Exhibit Attracts Many Lovers of Art / Western History Is Pictured by Artist," *Duluth (MN) News Tribune*, December 7, 1924: "Among some of the pictures now on exhibition in Duluth are many noted for their exquisite coloring, and their action. 'In the Enemy's Country,' a group of Indians traveling in the shadow of the foothills, to reach the buffalo country, is most true to history. Their horses are covered with buffalo robes, the Indians are walking between the horses, carrying their spears pointing groundward. All the details are faithfully reproduced by Mr. Russell, who has the art of putting greater spaces on his canvas than almost any other painter. 'The Wolf Man,' a princely Indian seated on his horse, ahead of his band, scouting for the enemy, is one of the most popular of the collection."

CHARLES M. RUSSELL
Wolf Men, 1925
Oil on canvas, 24 x 36
Collection of Tom and Jane Petrie

I began this essay with Russell's painting *In the Enemy's Country* to symbolize western art's current uneasy status. In it, Kootenai buffalo hunters move furtively across Blackfeet land. They know they are in hostile territory, and their goal is to attract no unwanted attention. Traditional western art appears to be in that position, too. But perhaps a different metaphor for western art can be drawn from Russell's work. He was never ashamed of what he did or embarrassed to be called an illustrator. At several exhibitions beginning in 1924, *In the Enemy's Country* was joined by another canvas that, at first glance, is similar in color, composition, and subject matter. *Wolf Men* shows a party of Indians proceeding along a rise above a sunlit valley. But they make no effort at concealment; the four lead figures are mounted—one on a conspicuous white horse—and fully framed against the sky. They are Blackfeet, a catalog description explained, "traveling through their own country"—certain of their rights and sure of their place in the world. Would that they could represent western art today, proud of its traditions and comfortable with what it is.[22]

Old West Meets New Art History

Some Reasons Why the Dust Hasn't Settled

William H. Truettner

From roughly the end of World War II until fairly recently, American art of the nineteenth and early twentieth centuries has been divided into two fields: western art and everything else. No other region in the country has had such a distinct artistic boundary drawn around it, nor has the style of painting that prevailed in any of these regions ever been described by scholars in such a singular way. Those interested in the art of the American West—especially scholars and collectors—have tended to see it as a more or less truthful account of the events associated with westward expansion. Or, when even the most faithful advocates of this theory have had to acknowledge that an image was more fiction than fact, truth was said to reside in the spirit of the image—the spirit that prompted would-be pioneers to set off for Oregon and California.[1] All but a handful of artists who pictured the American West between 1820 and 1920 made claims (or had claims made on their behalf) for this kind of verisimilitude—for recording the West, or the so-called spirit of westward expansion, with a fresh and attentive eye.

After the 1920s (or even before, if we acknowledge the comments and activities of those artists at the turn of the century who admitted that they were inventing an "Old West"), those painting the West began to soften their claim, acknowledging that the content of their pictures might be more symbolic than real.[2] But if their art was on the verge of revealing itself as something other than visual truth, scholarship addressing earlier western

1. In the preface to their extensive and well-illustrated survey of the Gilcrease western art collections, Paul Rossi and David Hunt write: "The illustrative material has been selected primarily for its value as a historical record . . . The spirit of the past is preserved in such records . . . they embody a great many facts, both essential and incidental, important to our understanding [of events that] shaped [life on the frontier]." See Rossi and Hunt, *The Art of the Old West, from the Collection of the Gilcrease Institute* (New York: Alfred A. Knopf, 1971), 15.

2. "I do not paint Indians . . . merely because they are picturesque," wrote Maynard Dixon in 1913, "but because through them I can express [to the world] that phantasy of freedom and space and thought . . . which is inspiring and uplifting." See California Academy of Sciences, *Maynard Dixon, Images of the Native American* (San Francisco: California Academy of Sciences, 1981), 45.

3. These include Joni L. Kinsey's *Plain Pictures: Images of the American Prairie* (Washington, DC: Smithsonian Institution Press for the University of Iowa Museum of Art, 1996); Nancy Anderson's *Frederic Remington: The Color of Night* (Washington, DC: National Gallery of Art, 2003); and Lisa M. Strong's forthcoming project, *Alfred Jacob Miller and the Art of the American West*, an exhibition and publication sponsored by the Amon

WILLIAM TYLEE RANNEY
The Pipe of Friendship, ca. 1885
Oil on canvas, 29.5 x 40.25
Private Collection

ERNEST BLUMENSCHEIN
Eagle Fan, 1915
Oil on canvas, 33.625 x 29.625
Denver Art Museum, William Sr. and
Dorothy Harmsen Collection

Carter Museum. Also important are
pathbreaking books by Alexander
Nemerov (*Frederic Remington and Turn-
of-the-Century America* [New Haven, CT:
Yale University Press, 1995]); Frank H.
Goodyear III (*Red Cloud: Photographs
of a Lakota Chief* [Lincoln: University
of Nebraska Press, 2003]); and Kenneth
Haltman (*The Forgotten Expedition:
Natural History, Documented and
Imagined in the Art of Samuel Seymour
and Titian Ramsey Peale, 1818–1823*
[State College: Pennsylvania State
University Press, forthcoming]).

4. "By 1906," Brian Dippie writes,
"Russell had already established himself
as the great eulogist of 'The West That
Has Passed,'" (see Dippie, *Looking at
Russell* [Fort Worth, TX: Amon Carter
Museum, 1987], 71). Dippie returns
to the subject in "The State of Russell
Scholarship," in *Charles M. Russell,
Legacy: Printed and Published Works
of Montana's Cowboy Artist*, ed. Larry
Len Peterson (Helena, MT: Twodot
Books, 1999), x–xi. Sadakichi Hartman
and Samuel Isham, who wrote the two
standard books on American art of
this period, gave extensive coverage to
American impressionism but barely
mentioned artists who painted western
subjects (see, respectively, *A History of
American Art* [Boston: L. C. Page, 1901]
and *The History of American Painting*
[New York: Macmillan, 1905]).

5. Richard H. Saunders, *Collecting
the West: The C. R. Smith Collection
of Western American Art* (Austin:
University of Texas Press, 1988), 9–51.

art took little notice. It remained, in the minds of those active in the field, an analogue to westward expansion. And therein, I would argue, lies the problem. Scholarship in all other areas of American art—those I have loosely grouped under the heading "mainstream"—was moving in a new direction. Those who sought to find in western art a truthful account of the winning of the West have had to cede ground in recent years to more advanced scholarship that promoted mainstream American art. And as the latter flourished, offering new insights into the work of artists such as Frederic Church, Winslow Homer, Thomas Eakins, and John Singer Sargent, western art scholarship served western art less well. Frederic Remington and Charlie Russell may have survived as truth-telling artists of the Old West, but the kind of scholarship that maintained them in such a position was, it now appears, something of a last stand. Scholars concerned with mainstream American art had already begun to search for different and more nuanced ways to discover meaning. These they proceeded to apply not to the issue of art as a documentary process but to art as a cultural process, in which the aims and ideals of the young nation were subjected to more wide-ranging scrutiny.

To investigate this problem further—the gulf that has opened between western art and mainstream American art—and to help us see it in a shifting historical context, I've divided this article into three parts. The first deals with the relationship between the two fields before 1950. The second begins about 1950 and proceeds through the 1980s, when I believe attempts were made to bring the two fields closer together. The third is concerned with more recent times, and how new projects, some completed, some still underway, are changing the western art landscape.[3] To some extent, my remarks will also rely on trends in private art collecting. What western art collectors have said about their acquisitions, for example, has been useful in guiding me through the time periods I've just outlined.

Before commenting on how western art was regarded previous to the 1950s, I should say that what I believe took place during the 1950s—the division of western and mainstream American art into separate fields—considerably oversimplifies the situation. What happened during the 1950s is that the two fields, already somewhat distinct, became further separated. That separation, I suspect, began around the turn of the century, when the notion of an Old West—a consciously constructed retrospective time frame for viewing the history of westward expansion—came into being. At that point, Remington and Russell seem to have carved out a special niche for themselves, one that scholars and collectors saw as different from the quieter, more genteel subjects painted by the impressionists and by other New York and Boston artists. Those who favored and/or collected the former seem not to have been interested in the latter and vice versa.[4]

PART I: BEFORE 1950

EVEN IN THE PRE-1950S ERA, however, we have the problem of knowing which artists, or, in some cases, which paintings (since some artists operated on both sides of the aisle) to include under the category of western art. Does it consist mainly of the so-called cowboy and Indian artists of the turn of the century, or does it reach further back, to major landscape and genre painters of an earlier era, or even back to those who painted Indians during the 1830s and '40s? There seems to be no sure way to answer such questions. One can only turn to Richard Saunders's important survey of western art collecting to get a sense of how the category was expanding.[5] Taos artists Ernest Blumenschein, Irving Couse, Joseph Henry Sharp, and Bert Phillips; landscape painters Albert Bierstadt and Thomas Moran; and animal painters (and sculptors), such as Carl Rungius and Edward Kemeys, were perhaps the first to be added to the new category, according to what began to appear on the walls (and on pedestals in trophy rooms) of private collectors. Earlier artists followed, most of whom were painters of Indians, such as George Catlin and Alfred Jacob Miller, and those who succeeded them, Seth Eastman and John Mix Stanley. By the 1940s and '50s, they were joined by George Caleb Bingham and William Ranney, whose work was first shown

at eastern art museums as genre painting, and later in collections of western art. A similar sequence holds true for works by Bierstadt and Moran. They first appear in museums and private collections as Hudson River landscape paintings and later, in the 1940s, with Remingtons and Russells as western art.

But that's just the point. The distinction between western and mainstream American art, although it was certainly apparent up through the 1940s, was not yet as firmly in place as it would be in the decade following World War II. By the 1950s, as Peter Hassrick has noted, there was a fresh burst of interest in the West, in the work of Remington and Russell, and in collecting western art in general.[6] This, I would argue, is the moment that scholars and collectors began to define a more distinct role for western art, based on how accurately it portrayed the era of westward expansion. Before addressing that moment, however, and the bonanza years for western art that followed, I want to return to the decades between the wars, the 1920s and 1930s. The activities of two major collectors of that period, Will Hogg in Houston and Maxim Karolik in Boston, tell us much about interest in American art during this time, although the men themselves remain something of an enigma. Hogg, as dapper and urbane in his photo as any easterner, actually grew up on the Texas frontier, prospered, and bought more than forty works by Remington between 1920 and 1930. Karolik, looking rumpled and craggy by comparison, married into an old Boston family in 1930 and became, over the next three decades, a remarkably versatile collector of mainstream American art.

GEORGE CALEB BINGHAM
The Squatters, 1850
Oil on canvas, 25 x 30
Museum of Fine Arts, Boston, Bequest of
Henry L. Shattuck in memory of the late
Ralph W. Gray, 1971.154

BELOW: WILL HOGG, 1930.
Museum of Fine Arts, Houston, Archives

MAXIM KAROLIK, 1963.
Photo by Steven Trefonides, Boston

5. Richard H. Saunders, *Collecting the West: The C. R. Smith Collection of Western American Art* (Austin: University of Texas Press, 1988), 9–51.

6. Peter H. Hassrick, "Western Art Museums: A Question of Style or Content," *Montana: The Magazine of Western History* 42 (Summer 1992): 30–33. See also William H. Truettner, "Ideology and Image: Justifying Westward Expansion," in *The West as America: Reinterpreting Images of the Frontier, 1820–1920,* ed. William H. Truettner (Washington, DC: National Museum of American Art, 1991), 39–40.

7. The most helpful overview of Karolik's life and collecting activities is Carol Troyen's "The Incomparable Max: Maxim Karolik and the Taste for American Art," *American Art* 7 (Summer 1993): 64–87.

WILLIAM SIDNEY MOUNT
Rustic Dance After a Sleigh Ride, 1830
Oil on canvas, 22.125 x 27.125
Museum of Fine Arts, Boston, Bequest
of Martha C. Karolik for the M. Karolik
Collection of American Paintings,
1815-1865, 48.458

If the two men don't quite look their parts, it's probably because each was playing a role for the camera. Karolik is standing in a decorative arts gallery at the Museum of Fine Arts, Boston, exhibiting, as it were, his dedication to building the museum's American collections. He and his wife, Martha Codman, had begun as collectors of eighteenth-century American decorative arts in the 1930s, adding rare pieces to the heirloom furniture already in their possession. Most of what they assembled decorated their colonial revival home in Newport until it was sold and the contents were given to the Museum of Fine Arts, Boston. Then Karolik abruptly changed directions. During the 1940s, he turned to what was at the time a neglected area of American painting—artists such as Bingham, William Sidney Mount, Thomas Doughty, Thomas Cole, and Jasper Cropsey, who filled the gap between colonial portrait painting and the proto-modern masters Homer, Eakins, and Albert Pinkham Ryder. By then, the Karoliks had turned private art collecting into a kind of public philanthropy—everything they bought would go to the Museum of Fine Arts, Boston, at the conclusion of each phase of their collecting: decorative arts in 1938, American paintings in 1949, and American drawings and folk art in 1962.[7]

Hogg, unlike Karolik, aspired to the role of a dandy in his photograph, seemingly eager to distance himself from the Texas "frontier." And that may be why he was somewhat ahead of Karolik in his desire to own early American furniture. Starting in 1920, Hogg and his sister Ima began acquiring seventeenth- and eighteenth-century American antiques at a rate that allowed them to simultaneously furnish a suite of offices in downtown Houston, a ranch house that was in the process of being colonialized, and several New York apartments. The collecting aims of Karolik and Hogg must have been somewhat different during those years: the former, proceeding at a discreet pace, was following a carefully prescribed Brahmin ritual; the latter, in more of a hurry, was trying to persuade newly rich Texans to raise their cultural sights. But it's probably safe to say that both parties saw collecting seventeenth- and eighteenth-century furniture as a way of staying in touch with the past and of promoting traditional American values in a rapidly changing modern world.

ABOVE: THOMAS COLE
River in the Catskills, 1843
Oil on canvas, 27.5 x 40.375
Museum of Fine Arts, Boston, Bequest
of Martha C. Karolik for the M. Karolik
Collection of American Paintings,
1815–1865, 47.1201

FREDERIC REMINGTON
The Flight (A Sage-Brush Pioneer), 1895
Oil on canvas, 23 x 33
Museum of Fine Arts, Houston, The
Hogg Brothers Collection, gift of Miss
Ima Hogg

8. Much of the information cited about Will Hogg and his family has been drawn from Emily Neff's important catalog *Frederic Remington: The Hogg Brothers Collection of the Museum of Fine Arts, Houston* (Houston and Princeton, NJ: Museum of Fine Arts, Houston, and Princeton University Press, 2000), 5, 16–17.

Before long, however, both Hogg and Karolik had gone off in new directions. What Hogg's photograph doesn't tell us is that he also took pride in his Texas origins. So he balanced his purchases of fine antiques with a stunning group of Remington paintings and sculptures, which he displayed, together with his antiques, in his downtown office in Houston. That way, as Emily Neff has noted, he promoted a marriage of the regional and the national, acknowledging, in effect, that Remington's views of an Old West brought alive for him the history of the region in which he had grown up.[8] But Hogg wasn't seeking history in the form of a chronicle told through paintings. Instead he was looking for, and apparently found, an affirmative view of life in the early Southwest, a view that featured the resourcefulness of those who had fought to survive in a none-too-promising landscape and climate. Or, one should say, Hogg found a mythic resourcefulness that Remington had invented for similar entrepreneurial patrons and that Hogg had already applied to his own business interests—drilling for oil, real estate development, and large-scale ranching and farming.

Despite the obvious differences between the collections Karolik and Hogg assembled, and the different backgrounds from which the men came, there were points of contact. Both, for example, began by collecting early American furniture. And both, before long, turned to less conventional fields. Karolik in the 1940s began acquiring mid-nineteenth-century American painting and folk art; Hogg, during the 1920s, bought so many Remingtons that he became the major private collector in the country of the artist's work. What is similar here? Both Karolik and Hogg were moving *down* the artistic ladder, from colonial furniture to artists who at that time had barely made it into museum collections. But more to the point: how did Karolik's reason for collecting mid-nineteenth-century American paintings connect with Hogg's view of his Remington collection? Both men were mavericks of a sort, despite their prominent positions in Boston and Houston. Karolik was, after all, a Russian Jew who had married into an old Boston family, all but one of whom refused to come to the wedding. And Hogg's father, governor of Texas from 1891 to 1895, was an outspoken populist who took the part of farmers and ranchers against railroads, big business, and urban power brokers. Whatever their politics, both Karolik

THREE REMINGTON PAINTINGS HANGING ABOVE A WINDSOR SETTEE IN WILL HOGG'S OFFICE FROM "AMERICAN FURNITURE OF EARLY DATE," CIVICS FOR HOUSTON 1 (JUNE 1928), BY DOROTHY M. HOSKINS
Courtesy Houston Metropolitan Research Center, Houston Public Library

and Hogg were progressives in their way, dedicated to improving their local communities.[9] And deep down in both was an anti-elitist strain—a concern for what became known in the 1930s as the common people. Karolik said as much in 1949, when trying to explain his collecting impulse. He saw art made between 1815 and 1865 as an expression of people who lived in pre-industrial communities, supported by the land or the sea. Those communities, he believed, were wellsprings of democracy; pictures of them and their inhabitants, at work and play, captured the very essence of that phase of American life.[10]

Preserving a make-believe past seems to have led to a museum destination for both collections. The Karoliks, almost from the start, intended to give their collections to the Museum of Fine Arts, Boston, and in 1944, Hogg's sister Ima gave his Remington collection to the Museum of Fine Arts in Houston. The American furniture at Bayou Bend, the Hogg family's now-famous home in River Oaks, followed in 1957.[11]

PART II: AFTER 1950

STRICTLY SPEAKING, Karolik had no followers. Those who collected pre-twentieth-century American art from the late 1960s through the 1980s—Mr. and Mrs. J. William Middendorf, Mr. and Mrs. John D. Rockefeller III, Barbara Babcock Millhouse (for Reynolda House), Jo Ann and Julian Ganz, Richard Manoogian, and Daniel Terra, among others—didn't restrict themselves to a narrow time frame.[12] They bought across the board, sometimes starting in the eighteenth century and continuing through the early twentieth. And their collecting motives stressed pride in the rise and progress of American art, from humble beginnings to a formidable national school (which over time turned their American art into a valuable asset). Paintings that appear in catalogs of these collections and in museum and trade catalogs of the same period were said to represent "The American Vision," "The American Experience," "An American Perspective," "American Light," and an "American Paradise," phrases that bring to mind the titles of books written during the same years by Daniel Boorstin (*The Americans: The National Experience*, 1965; *The Americans: The Democratic Experience*, 1973) and other consensus historians of the period.[13] Read more closely, these catalogs seek to match American artistic accomplishment with a narrative of national accomplishment. Most argue, along with the historians, that the conditions of life in the newly independent nation (guaranteed by self-government and economic opportunity) promoted core beliefs in national unity and individual freedom—beliefs

that were high-minded enough to encourage artistic production but that could, and often did, come into conflict. When that happened, historians like Boorstin claimed, America had a built-in capacity to cope; it could resolve tensions by restructuring government and society as often as necessary. "New Beginnings" became the rather homespun process that enabled the new nation to survive and prosper.[14] Carried forward to the post–World War II era, this view of national history seems to have encouraged many American collectors to embrace their national school. Indeed, one senses that they saw these arguments as both retrospective and current—that past "adjustments" (read accomplishments) were being used to explain how the United States had arrived at a position of economic and cultural superiority during the years these collections were being assembled.

Another strong message in these catalogs, not unrelated to the previous one, urges readers to recognize the aesthetic merit of pre-twentieth-century American art.[15] For all Karolik's fascination with the paintings he was collecting, one suspects that he never took them as seriously as, say, fine eighteenth-century furniture or the work by the Homer-Eakins-Ryder generation that followed the point at which he stopped collecting.[16] But during the post–World War II period, American art on both sides of this generation received considerable praise, not only for itself but as a lead into the twentieth century, when American modernism was said to have "triumphed."[17] In the academy, the scholarship of Barbara Novak, among others, supported the approach of postwar collectors of earlier

9. Neff, *Frederic Remington*, 12–16.

10. Museum of Fine Arts, Boston, *M. and M. Karolik Collection of American Paintings, 1815–1865* (Cambridge: Harvard University Press, 1949), xiv.

11. David B. Warren, *Bayou Bend: American Furniture, Paintings, and Silver from the Bayou Bend Collection* (Boston: New York Graphic Society for the Museum of Fine Arts, Houston, 1975).

12. For catalogs or descriptive summaries of these collections, see: Metropolitan Museum of Art, *American Paintings and Historical Prints from the Middendorf Collection* (New York: Metropolitan Museum of Art, 1967); Edgar P. Richardson, *American Art, An Exhibition from the Collection of Mr. and Mrs. John D. Rockefeller III* (San Francisco: M. H. de Young Memorial Museum, 1976); Charles C. Eldredge and Barbara B. Millhouse, *American Originals: Selections from Reynolda House, Museum of American Art* (New York: Abbeville Press, 1990); Thomas Andrew Denenberg, "American Art at Reynolda House," *American Art Review* 17 (June 2005): 88–95; John Wilmerding, Linda Ayres, and Earl A. Powell, *An American Perspective: Nineteenth-Century Art from the Collection of Jo Ann and Julian Ganz, Jr.* (Washington, DC: National Gallery of Art, 1981); Detroit Institute of Arts and the National Gallery of Art, *American Paintings from the Manoogian Collection* (Washington, DC: National Gallery of Art, 1989); and National Gallery of Art, *An American Point of View: The Daniel J. Terra Collection* (Giverny, France: Musée d'Art Américain Giverny Publications, 2002).

13. *The American Vision* and *The American Experience* are, respectively, titles from catalogs published by Hirschl and Adler Galleries, New York, in 1968 and 1976. *American Light: The Luminist Movement, 1850–1875,* organized by John Wilmerding, was held at the National Gallery of Art, Washington, D.C., in 1980. *American Paradise: The World of the Hudson River School* was organized by the Metropolitan Museum of Art, New York, in 1987. *An American Perspective,* cited above in n. 12, is the title of an exhibition of the Ganz Collection.

14. Daniel Boorstin, *The Americans: The National Experience* (New York: Random House, 1965), v. Art historian John Wilmerding, when interviewed in 1981 about the *American Light* show, closely followed Boorstin's lead in describing the past: "From the very beginning of our history," Wilmerding said, "Americans kept telling themselves that America was a new beginning." Americans differ on many things, he continued, "but a thread of unity runs through the nation." There is in the nation's art "a sense . . . of our natural resilience" and of our "optimism." These are "beliefs and attributes that have always stood us well." See David Shribman, "Expert Views Politics' Ties to Paintings," *New York Times*, October 20, 1981, sec. A. See also Allen F. Davis and Harold D. Woodman, *Conflict and Consensus in Modern American History*, 3rd ed. (Lexington, MA: D. C. Heath, 1972), xxii–xxiv.

15. Like many other scholars of this era, Theodore Stebbins sought to promote connoisseurship as a key to studying and understanding American art. In the foreword to his *New World* catalog (see below), Stebbins revealed that initially the exhibition was limited to nine American painters (John Singleton Copley, Thomas Cole, Frederic Edwin Church, Martin Johnson Heade, Fitz Henry Lane, George Caleb Bingham, Thomas Eakins, Winslow Homer, and William Harnett). Only "masterpieces," he claimed, would convince audiences (especially those in Paris, the last venue) of the importance of American art. Subsequently, the number of artists (and paintings) was enlarged. But an art survey of American life or history was not what Stebbins intended. Instead, he wished to demonstrate "an important but seldom-noted aspect of American history: the rise of an American art." See Theodore E. Stebbins Jr., Carol Troyen, and Trevor J. Fairbrother, *A New World: Masterpieces of American Painting, 1760–1910* (Boston: Museum of Fine Arts, 1983), 8–12.

16. *M. and M. Karolik Collection*, ix–x (see n. 12). Karolik, of course, never made such distinctions. He maintained that he and his wife were collecting American paintings done between 1815 and 1865 on the basis of "artistic merit," the same judgment they applied to their other collections. But a closer reading of his remarks suggests that he was trying to prove to "doubters and skeptics" that although the art of that period lacked "abstract beauty," it was nevertheless "fascinating" in its "simplicity and directness of expression."

17. Irving Sandler, *The Triumph of American Painting: A History of Abstract Expressionism* (New York: Praeger, 1970).

American art. In two influential books, she attempted to isolate an American aesthetic—a set of uniquely national stylistic traits that appeared in the work of a range of artists (a few of whom painted the West) from the eighteenth century to the beginning of the twentieth.[18] In the years that followed, other academics were developing a more contextual approach to American art, contextual in the sense that they wished to locate works of art more firmly in the social and cultural beliefs of the artist's own time.[19] Those beliefs (or points of view) weren't necessarily "mirrored" in a work, these academics argued. More often, they became evident as ideologies—as visual language unobtrusively, and often obliquely, shaped to offer one or more points of view. Understanding how this language subtly persuades viewers to accept the face value of an image—its familiar and commonplace meaning—encouraged scholars to challenge the process. They pursued instead what these images didn't seem to say, what they in effect diminished or erased, in order to construct a more accommodating past. Once embarked on this new approach, however, issues of truthfulness, style, and connoisseurship have no more (or less) critical weight than other leads a scholar might wish to follow. Each lead is used with the same purpose in mind—to draw from the image or images under consideration an enriched viewing experience.

LET ME SUMMARIZE, at this point, by saying that in the last twenty years or so, scholarship addressing mainstream American art has proceeded from efforts to single out and extol a national style to a more complex investigation of how art-making and American history have interacted over three centuries. With that in mind, let us review western art collecting and scholarship over these same post–World War II decades. Many of those who had been active collectors before the war, such as Thomas Gilcrease, Amon Carter, and C. R. Smith (the last, a businessman who founded American Airlines), continued on into the 1950s and 1960s. This was also the period in which western art became institutionalized, not only in books and catalogs but literally, in bricks and mortar, with the founding of the Gilcrease and Amon Carter museums and the Whitney Gallery of Western Art in Cody, Wyoming.[20] Underlying this new phase of museum building was a brand of scholarship that we can trace back to Harold McCracken, the first director of the Whitney Gallery. In 1952, McCracken published a book called *Portrait of the Old West*. He wrote the book, he says in the preface, to use images as documents to tell the story of the Old West, from the sixteenth through the nineteenth centuries.[21] He also says, so that no one can mistake his aim, that he's not concerned with making value judgments about the work of the artists who appear in the book. But that's not quite true. Remington is cast as a great artist because he had an eye for detail and the skill to depict accurately what he saw. Others mentioned in the text are ranked in a hierarchy that descends from Remington to those with less focused eyes or less exacting techniques. Despite these personal assessments of artistic skill, McCracken surely believed that aesthetics and history were not comfortable bedfellows; the more "pictorial" a painter's style, the less factual his work tended to be, and what McCracken most wanted from western artists was a reliable historical narrative.

McCracken's message is now fifty years old and still going strong in some quarters. It was updated and refined by other scholars in the 1960s and '70s, but basically their approach remained the same: add up the details of an image to see if they create a general impression of truth. I go on at length about this because I don't think Hogg saw his Remingtons in that way—as day-to-day chronicles of an Old West. Instead, he hung them on the walls of his office as a then-and-now look at the region, a comparison that fixed the "now" (a thriving business environment) as an extension of an inspirational past.

What is more of a holdover from Hogg's time to postwar collecting is the assumption that Remington's paintings could be seen as inspiring models of frontier life—especially in the postwar West. The notion of western art as a chronicle was a helpful foundation for this model. So was a strong measure of Cold War patriotism. The chronicle, after all, measured progress—the growth of western timber, mining, and oil interests, and the development of regional transportation, commerce, and industry. These material

18. See Barbara Novak's *American Painting of the Nineteenth Century: Realism, Idealism, and the American Experience* (New York: Praeger, 1969) and her *Nature and Culture: American Landscape and Painting, 1825–1875* (New York: Oxford University Press, 1980).

19. Publications that come to mind (a few of which touch on western art issues) are: Wanda Corn, "Coming of Age: Historical Scholarship in American Art," *Art Bulletin* 70 (June 1988): 188–207; Patricia Hills, *The Painters' America: Rural and Urban Life, 1810–1910* (New York: Whitney Museum of American Art, 1974) and Hills, *The American Frontier: Images and Myths* (New York: Whitney Museum of American Art, 1973); Elizabeth Johns, *American Genre Painting: The Politics of Everyday Life* (New Haven, CT: Yale University Press, 1991) and Johns, "La Farge and Remington," *Art Journal* 47 (Fall 1988): 241–43; Jules David Prown, "Mind in Matter: An Introduction to Material Culture Theory and Method," *Winterthur Portfolio* 17 (Spring 1982): 1–19; Roger B. Stein, "Packaging the Great Plains," *Great Plains Quarterly* 5 (Winter 1985): 5–23; Alan Wallach, "Thomas Cole and the Aristocracy," *Arts Magazine* 56 (November 1981): 84–106; and Bryan Jay Wolf, *Romantic*

THOMAS MORAN
Green River, Wyoming, 1879
Oil on canvas, 26 x 62
Private collection

Re-vision: Culture and Consciousness in Nineteenth-Century American Painting and Literature (Chicago: University of Chicago Press, 1982).

20. The Gilcrease Museum and the Whitney Gallery were founded, respectively, in 1949 and 1959. The Amon Carter Museum followed in 1961. See Saunders, *Collecting the West,* 45–49.

21. Harold McCracken, *Portrait of the Old West* (New York: McGraw-Hill, 1952), 7–8, 209–16. A similar approach to western art can be found in another influential book of this period, Robert Taft's *Artists and Illustrators of the Old West, 1850–1900* (New York: Scribner, 1953).

22. A. B. Guthrie Jr., *The Way West* (New York: Houghton Mifflin, 1949; reissued in 2002), 154.

benefits appeared to be the natural outgrowth of a frontier spirit. Give a man space and freedom, provide him a measure of bounty, and test him with the hardships of pioneer life. If he survives and prospers (it was always a "he"), an Old West transforms itself into a New West, with its values intact. Novelists, western movies, and TV dramas of the postwar era helped foster this scenario. In *The Way West,* for example, A. B. Guthrie's Pulitzer Prize-winning 1949 novel about a family moving West a hundred years earlier, we find a strong endorsement of pioneering as the way to success. Guthrie's protagonist is a Missouri farmer named Lije Evans, who chafed at spending the rest of his life on a quarter section of land that was only marginally productive. So he persuaded his family to join a wagon train to Oregon. Once on the way, Evans develops strengths he never knew he had, takes charge of the train, and leads his family and fellow travelers safely over the mountains to a new and better life. What drives Evans, according to Guthrie, is his restless spirit, his need to fulfill himself, and his desire to find his rightful place in a promising new land. Looking back at the train one day, Evans tries to express all this: his own pride in the undertaking and in those he's leading. He sums it up as "onwardness"—a deep-seated will or spirit that "wasn't a thing for reason . . . but for the heart, where secrets lay deep and mixed." No words could describe such a feeling, Evans claimed: it simply "came to" a man when he began to find his role in such a "wide and wealthy" country.[22]

What came to a man at the same time, Evans might as well have said, was the desire to appropriate a share of that prospective wealth. The Cartwright family, a pioneer father and three burly sons who ran a large cattle ranch in a 1960s television program called *Bonanza,* acted out that part of Lije Evans's desire. A decade later, William Foxley, a cattle baron of a different kind, was buying a wide-ranging and impressive collection of western art, which he installed in a handsomely remodeled old building in downtown Denver. In 1983, Foxley published a catalog of his collection, written by himself and dedicated to his father, whom the son extols as "A Pioneer Cattleman, A Personification of the Spirit of Self-Reliance and Optimism Prevalent on the Frontier." Western history begins, Foxley continues in the preface, when Coronado "took quill in hand to write of his search for gold." But the best stories that follow, Foxley says (echoing McCracken), are those told by the exceptional

group of artists represented in his collection. These artists, he maintains, are especially good narrators of the period between the battle of Gettysburg and the Korean War (1863–1950), when the West became an "efficient world breadbasket," and America grew to become the "world's greatest military and industrial power."[23]

Foxley's claims for his collection were not exactly modest, and many would argue that his account of nine decades of American economic development leaves out a number of rough patches. But looking back at the collection today, scholars and collectors would agree that the quality and range of the works he gathered were remarkable. Foxley's ambition went beyond that of most of the generation that spanned World War II—those who mainly collected cowboy and Indian images of the turn of the century. If he had a model, it was perhaps Thomas Gilcrease, whose collection ranged from artists who painted Indians in the 1830s and '40s through those who worked in Taos and Santa Fe between 1900 and 1940. But Foxley was more quality-conscious than Gilcrease. The latter bought in quantity; Foxley bought selectively, as if, like his mainstream colleagues, he believed that a collection of superior paintings would require scholars and critics to take the field more seriously. His acquisitions included one of the few Karl Bodmer watercolors that escaped the collection of Prince Maximilian, Bodmer's German patron; a large and impressive Green River painting by Thomas Moran; a Bingham raft picture; a stunning array of Remingtons and Russells, including Remington's *Downing the Nigh Leader*; a cruciform cow's skull by Georgia O'Keeffe; and Grant Wood's *Spring Plowing*.

What Foxley didn't do was venture beyond artists he considered "western." But that also makes him more typical of postwar collectors in both fields, western and mainstream, who crossed over less frequently than their predecessors. Indeed, by the late 1970s, the collectors themselves seem to have divided the fields. Either they bought western or they bought mainstream American art, but rarely both. In the important mainstream collections formed during the 1970s and '80s, fewer and fewer western paintings appeared. And those that made the cut were the ones that could meet mainstream standards of quality. Which means, of course, that they weren't necessarily acquired because they were western, but because they were considered beautiful paintings.

[23]William C. Foxley, *Frontier Spirit: Catalog of the Collection of the Museum of Western Art* (Denver: Museum of Western Art, 1983), vii, xi.

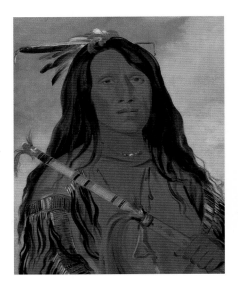

GEORGE CATLIN
Né-hee-ó-ee-wóo-tis, Wolf on the Hill, Chief of the Tribe, 1832
Oil on canvas, 29 x 24
Smithsonian American Art Museum, Gift of Mrs. Joseph Harrison Jr.

FACING PAGE:
ALBERT BIERSTADT
Indians Traveling near Fort Laramie, 1861
Oil on canvas, 23 x 40.125
Courtesy of the Anschutz Collection, Denver

GEORGE CATLIN
Buffalo Chase, Mouth of the Yellowstone, 1832
Oil on canvas, 24 x 29
Smithsonian American Art Museum, Gift of Mrs. Joseph Harrison Jr.

SETH EASTMAN
Chippewa Indians Playing Checkers, 1848
Oil on canvas, 30 x 25
Courtesy of the Anschutz Collection, Denver

Scholarship in the decades following World War II tended to reinforce the growing distance between the fields. In the major American art texts written just after the war, by Oliver Larkin (1949), Virgil Barker (1950), Edgar Richardson (1956), and James Thomas Flexner (1962), the space devoted to western art is a few pages at most, with a selective nod to artists who managed to add a forceful drama to their reporting. Catlin's portraits, for example, were said by Flexner to have "great originality and power." They featured bold colors, spontaneous brushwork, and broad flat face planes that gave them a distinctly modern look. And yet, the general tone of the writing suggests that these painters occasionally did good work in spite of themselves and that painting Indians wouldn't necessarily advance one's career. "Among savages," Flexner remarks, "Catlin found theoretical support for his congenital unwillingness to study in any accepted school." Thomas Cole's landscapes, on the other hand, were seen as thoughtful, poetic, and forward-looking. Younger artists, Flexner claims, saw Cole's work as an "exalted . . . bridge" between tradition and innovation.[24]

It wasn't these authors, however, or even McCracken who managed to claim a broadly scientific (or, in the case of Indian portraiture, a more narrowly ethnographic) role for western art. It was John Ewers, an eminent Smithsonian anthropologist, who had worked among Upper Missouri tribes during the 1940s. His still-useful *Artists of the Old West*, written in 1965, became the textbook for the field.[25] In some ways, Ewers followed McCracken's approach—from Catlin through Remington, he saw western art as a visual record of the western scene. But Ewers, a former art student, was less interested in pictures forming a chronicle than in pictures capturing individual subjects—people, events, or places—in a fresh and lively way. His task, he believed, was to show how accurately artists had conveyed the experience of their new encounters—or, conversely, which ones were telling tales from eastern studios. To Catlin's portraits, he gave high marks, but expansive Bierstadt landscapes, in which topography had been dramatically reconfigured, he dismissed as overstating the case.

PART III: RECENT TRENDS

WHILE A MAIN THREAD OF WESTERN ART SCHOLARSHIP still connects Ewers with the way some scholars and collectors understand western art, there have also been periodic departures. During the mid-1960s and early 1970s, western art was given a broader context in several major museum exhibitions, including the Whitney Museum of American Art's *Art of the United States: 1670–1966* and the Metropolitan Museum of Art's *Nineteenth-Century America*.[26] Early and midcentury artists who went West were called artist-explorers, and they provided audiences back East with views of a vast, unspoiled early America, where Indians and buffalo still roamed free. But what scholars by then had come to realize was that many of these artists saw themselves preserving, as well as recording, native peoples and wild scenery that couldn't last long in their current state. This gave western art scholarship a new direction: no one records so-called vanishing races (and wilderness) without turning back the clock a bit, erasing evidence of change. And acknowledging erasure began to complicate the old formula for understanding western art. Instead of insisting that it re-created a real West, scholars began to see western art in a more symbolic role, picturing an Old West that never was. This was a breakthrough of no small importance. A few years later the term "myth" was applied to western art in another Whitney Museum exhibition, seemingly to draw a more careful distinction between an ideal West (the Old West that never was) and the so-called real West. But not until 1991, in *The West as America*, was myth linked with ideology.[27]

Other attempts to promote the field (or in the next two cases, to upgrade the standards by which it was judged), were the 1988 Remington show and catalog and the more recent (2001) catalog of the Anschutz Collection by Joan Carpenter Troccoli. Both

24. The full titles are: Oliver Larkin, *Art and Life in America* (New York: Rinehart, 1949); Virgil Barker, *American Painting: History and Interpretation* (New York: MacMillan, 1950); Edgar P. Richardson, *Painting in America: The Story of 450 Years* (New York: Crowell, 1956). For James Thomas Flexner's remarks, see his *That Wilder Image: The Painting of America's Native School from Thomas Cole to Winslow Homer* (Boston: Little, Brown, 1962), 87, 82, 58.

25. John C. Ewers, *Artists of the Old West* (New York: Doubleday, 1965; reissued with additional chapters in 1973). See also Ewers, "Fact and Fiction in the Documentary Art of the American West," in *The Frontier Re-examined*, ed. John Francis McDermott (Urbana: University of Illinois Press, 1967), 79–95.

26. Lloyd Goodrich, *Art of the United States: 1670–1966* (New York: Whitney Museum of American Art, 1966), 25–26; John K. Howat and John Wilmerding, *19th-Century America: Paintings and Sculpture* (New York: Metropolitan Museum of Art, 1970), xii.

27. See Hills, *The American Frontier*, and Truettner, *The West as America*, 39–40.

28. Michael Edward Shapiro and Peter H. Hassrick, *Frederic Remington: The Masterworks* (New York: Abrams, 1988). For a review of the show and catalog, see Johns, "La Farge and Remington," 241–43.

29. Joan Carpenter Troccoli, *Painters and the American West: The Anschutz Collection* (Denver and New Haven, CT: Denver Art Museum and Yale University Press, 2000), 76–79.

catalogs argue that juxtaposing western art and western history has caused viewers to neglect the formal qualities in western art—that is, to fail to recognize that western art has independent status as art. In an attempt to remedy the situation, the Remington show was called *Frederic Remington: The Masterworks*, and it did indeed offer an impressive overview of Remington's work, both in painting and sculpture.[28] The catalog followed suit, opening with a brief but useful historical setting by David McCullough, after which the curators turned to style and to comparisons with artists outside the field to prove their point. But that in turn raises the question of how effectively style (or formal) analysis alone can demonstrate quality. Can it tell us, without a broader look at a work's historical meaning, how the work was regarded in the artist's own time, or how we should regard it today? The catalog of the Anschutz Collection, *Painters and the American West*, takes a similar line. The prescription for recognizing western art as great art, it argues, is to place it in the proper artistic genealogy—to show how it's related to the great masters of Western (with a capital *W*) art.

One prominent candidate for inserting in this genealogy is George de Forest Brush's *The Picture Writer's Story* (1884). The actual picture writer, the monumental figure in the center of the composition, is a direct borrowing from Michelangelo's *Libyan Sibyl*. The borrowing was featured in the show and catalog, presumably with some hope that the luster of a great Renaissance artist would transfer to Brush's work. It was also done, the catalog states, to encourage viewers to see it not as a western (with a lowercase *w*) picture but as one that would fit comfortably into mainstream American art.[29]

But what does this really accomplish? Are we to assume that up to now we've underestimated Brush's work, that he deserves greater recognition than he has received? Or does that miss the point? Can we instead see him as a good, indeed very good, painter in his own right, with aims different from those we're trying to impose on him? We might begin by asking what Brush hoped to achieve by representing the picture writer with such heroic proportions. We can probably assume that this was Brush's version of a noble warrior, who in this case is seen explaining his military triumphs (or those of his tribe) to two young braves (probably his sons). The subject amounts to a rite of passage—one generation passing on to the next the values and obligations of tribal life, as if they are a key to survival, to perpetuating the race. But why at this time (1884) would Brush choose to paint such a subject? Plains Indians were by then a beleaguered lot, mostly confined to reservations, where they were presumably being trained for entry into a white world. Clearly, this is not the story Brush wished to tell. But was he, in his own way, trying to perpetuate the race? Was he turning back the clock to a mythic time when Indians, such as the picture writer, did indeed rule the Plains? And was that the image that fascinated Brush and his contemporaries—heroic Indians who constantly tested themselves on the battlefield, told here as a quiet recollection but in more strident tones by Remington and Russell?

Whatever the answers, this kind of Indian did live on, in paint and bronze and on coins. And the image came to symbolize an older America, a society of noble warriors whose courage and determination inspired generations of white frontiersmen, up to and including surrogates like Teddy Roosevelt. But in a way, that simply tells us that Brush and his patrons had a remarkable double vision when they focused on Indian life. What they seemed so ready to believe was that noble warriors, who lived in mythic time, had at some point parted company with "real" Indians, who lived, much less nobly, in the present. There, real Indians languished between the mythic past that whites had invented for their ancestors, and white civilization, which few Indians considered a tolerable alternative.

Now, the question is: does Brush's reference to Michelangelo make more sense when explained this way or when it's used to present *The Picture Writer's Story* as a far better work than we had supposed? I should quickly add here that both approaches begin to remove the work from the category of reportage, to nudge it in the direction of mainstream scholarship. But can we make both work together, instead of going their separate ways? The kind of analysis that I applied to *The Picture Writer's Story* looks for meaning in the Indian

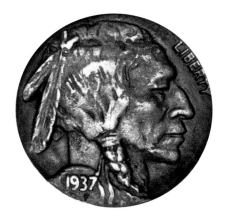

JAMES EARLE FRASER
Buffalo Nickel, 1913
Bronze, 4.5 in diameter
Untied States Mint image

issues of Brush's own time—those he was surely aware of but that he hesitated to confront directly. In that sense, I've tried to see the painting not just as art history but enclosed in a web of social and political history, to suggest that the immediate subject can convey a number of different meanings. But what about aesthetics; how does Brush make pictorial use of his artistic skills? Can we say that the story tells itself in the forms Brush chooses—in the heroic proportions of the picture writer and in his pose, beautifully adapted to the shape of the buffalo robe stretched behind him? Beside him sit two young Indians, languid and effeminate, who have the appearance of "unformed" youth. What will give them substance (literally "form" them, perpetuate them as mature symbols of Indian-ness), is the model of the picture writer and the exploits of manhood, inscribed on the buffalo robe, that he relates to the youths. The aesthetics of space and light (or lack of it) also govern our understanding of this event: the cavelike interior, ancient and timeless, makes it difficult for us to discover a present, a time that is known and familiar.

What I've just presented is the kind of analysis that has been applied to mainstream American art for years. We speak of Homer, Eakins, and Sargent "industries" to convey the idea that these artists are under similar and continuous scrutiny. But such analysis has rarely been applied to western art, I suspect because scholars of mainstream art believe that it can be more successfully applied to mainstream paintings—those paintings, in other words, with an aesthetic dimension that can support more complex historical interpretation. At the same time, western art scholars, concerned that western art is not getting sufficient recognition, look for ways to improve its standing. They draw on the traditional tools of art history—style and connoisseurship—to convince other scholars of its importance, or conversely they stress its truth-telling capacity. But aren't we missing here what a more open study of art of the American West could achieve? And if we are, haven't we got to admit that 1) art doesn't really tell the truth, and 2) aesthetic rankings have limited value? The former is more or less acknowledged by now, but the latter is a bit more complicated. Connoisseurship may be helpful in making distinctions within certain finite categories: one Remington painting may be better than another for certain quantifiable reasons. But if such rankings take on a broader application, if, for example, they claim hegemony across a field, they begin to discourage scholars from investigating anything but so-called masterpieces. To say that all works of art must be judged under an absolute system is, in its way, as hopeless as trying to deny that scholars are not already involved in a quality-conscious system. But if we are, our role as scholars requires us to recognize the problematic relationship between that system and the search for historical meaning.

One last remark. I think there's a nagging suspicion in some quarters that critical scholarship will add to the also-ran quality of western art. That is, if you say *The Picture Writer's Story* is a white man's fable about Indian life, the painting will have an even more difficult time getting the recognition it deserves. I would answer instead that seeing the work in a broad historical context tells us that Brush has created a moving, powerful, and complex painting. Should we now go on to proclaim its aesthetic merits, as if they exist independent of the circumstances I've just described? Or would this be making value judgments that won't really help us come to a better understanding of the work—that may, in fact, make our task more difficult? Needless to say, I'm arguing for aesthetic strategies that are timely and local and can be seen in terms of a historical context that enriches our appreciation of western art. That approach, I believe, will eventually break down barriers between the two fields. In the meantime, scholars on both sides of this argument will continue to stir up dust. That, after all, is what we're supposed to do.

As always, my thanks to Roger Stein and Alan Wallach for helping me improve the clarity and sequence of my arguments.

In the early 1980s, real estate developer and oilman Donald Todd commissioned pop artist Red Grooms to create a large-scale painted aluminum sculpture for a new residential/office center in downtown Denver. Grooms produced *Shoot-out*, a fourteen-foot-tall, twenty-five-foot-long, and three-thousand-pound piece that lampoons two American characters seemingly lifted from the frames of a B-grade Hollywood western: a cowboy and an Indian, fighting to the finish atop a ramshackle wagon. The artist's first outdoor sculpture project, *Shoot-out* was installed in September 1982 in the courtyard of the Lawrence Street Residences, a condominium complex located between 14th Street and Speer Boulevard. "That was a great place for the sculpture," Grooms later remarked. "The plaza was a very cool, very corporate-looking place and *Shoot-out* brought a lot of funky energy onto the scene." Within just a few months, however, *Shoot-out* was moved to another site, ostensibly because prospective tenants complained that it was "too large" and "too gaudy" and they "weren't sure they wanted to wake up in the morning and see that sculpture."[1]

Shoot-out

Poking Fun and Challenging Myths in Western American Art

Erika Doss

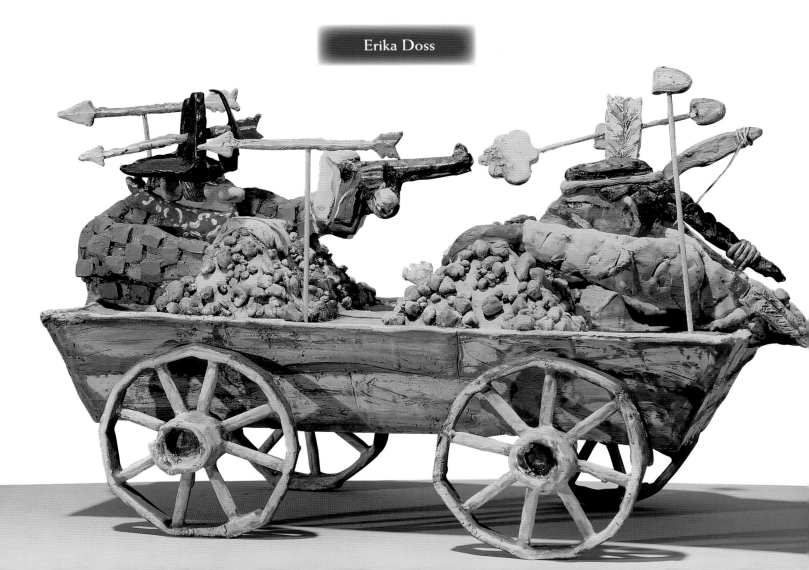

ALEXANDER PHIMISTER PROCTOR
Indian Warrior, 1898
Bronze, 38.5 x 8.375 x 27.5
Denver Art Museum,
Gift of Sharon Magness

FACING PAGE: RED GROOMS
Shoot-out, 1980
Painted bronze, 11.5 x 9.5
Private Collection, Denver and
©Red Grooms/Artist Rights Society (ARS),
New York

1. Red Grooms quoted in Carter
Ratcliff, *Red Grooms* (New York:
Abbeville Press, 1984), 223; and
prospective tenants quoted in Irene
Clurman, "Shifting Fate for Grooms'
Shoot-out," *Rocky Mountain News,*
November 22, 1982, sec. E.

2. Joanne Ditmer, "Must Public Art
Be Safe, Predictable, Inoffensive?" *The
Denver Post,* October 1, 1983, sec. B.

3. Berny Morson, "Artists Crash
Protest, Indians Decry Pop Sculpture,"
Rocky Mountain News, September 29,
1983.

4. *Shoot-out* was permanently gifted
to the museum in 1985. The label
included this comment: "Someone who
has never seen a Hollywood Western,
for instance, would certainly miss part
of Grooms' meaning. He would not
be able to see the work as a lampoon
of the popular movie stereotypes that
have helped make a Disneyland of the
American past."

5. Peter H. Hassrick, "Introduction,"
this volume.

6. The Talk of the Town, *New Yorker,*
May 31, 1976, 29, as noted in Ratcliff,
Red Grooms, 161.

Relocated a few blocks away to Triangle Park, a highly visible tract of land owned by the University of Colorado on its Auraria campus, Grooms's vividly painted parody encountered further resistance. Within weeks of its second unveiling, in August 1983, *Shoot-out* was targeted by students and faculty for promoting degrading stereotypes of American Indians and for belittling the American West's history of violent confrontation. "The winning of the West is not humorous, and resulted in a near genocide of the Native Americans," stated political science professor Glenn Morris, a Shawnee Indian, at a protest rally attended by more than a hundred people, many of whom demanded *Shoot-out*'s removal.[2] One student said he'd "paint it black" if *Shoot-out* wasn't removed; others vowed to use dynamite. Reversing their original position on *Shoot-out,* the University of Colorado Board of Regents declared the sculpture "inappropriate" for the campus and insisted that Todd's development group take it back.[3] Offered to the Denver Art Museum on long-term loan, *Shoot-out* was installed for a third time in a secluded corner of the museum's sculpture garden, accompanied by a lengthy descriptive label prepared with the input of members of the local Native American community.[4]

The controversy over *Shoot-out* hinged on assumptions that Grooms's cartoonlike sculpture reinforced racist stereotypes of American Indians and reaffirmed an odious history of injustice and oppression in the American West. But *Shoot-out* also patently refused to conform to stereotypical assumptions about western American art itself. For audiences accustomed to the representational and seemingly "documentary" works of heralded western artists such as Frederic Remington and Charles Russell, and thus to art that narrates what Peter Hassrick describes as a heroic "frontier mythos" of conquering and taming the Wild Wild West, *Shoot-out* was disturbingly different: too farcical, too "modern."[5] For viewers invested in similarly mythologized and romanticized representations of Native American subjects as exceptionally noble and spiritual beings, as depicted in bronze sculptures ranging from Alexander Phimister Proctor's *Indian Warrior* (1898) to Harry Jackson's *The Seeker* (1978), Grooms's sculpture was seen as a disrespectful affront. *Shoot-out,* of course, plays against both sets of assumptions. While its origins, like those of much western American art, lie in popular-culture stereotypes about the American West's peoples and landscapes, *Shoot-out* intentionally subverts those familiar assumptions to suggest different, more critically engaged, and, for some viewers, more threatening, understandings of the nation's "frontier mythos."

As a pop artist with an excellent grasp of art history, western American history, and popular culture—and with a longstanding objective of poking fun at it all—Grooms deliberately shaped *Shoot-out* on irreverent and provocative terms. Its distorted forms and burlesque sensibility are typical of the large-scale installations he began producing in the 1970s, including *Ruckus Manhattan* (1975) and *Ruckus Rodeo* (1976), epic projects that Grooms describes as "sculpto-pictoramas" and that some critics liken to "sculptural comic books."[6] *Shoot-out* is a similarly clunky and audacious dioramic spoof painted in garish colors; an ungainly, operatic vignette featuring two foolish figures crammed together on a ridiculous stage. Crouching behind little hills of gold-colored rocks—fool's gold, no doubt—each stereotyped figure clutches his equally stereotyped weapon of choice. Costumed in a checkered flannel shirt, a buckaroo bandana, and a ridiculously large black Stetson, the cowboy grasps a huge six-shooter with his meaty hand, an oversized thumb—the visual equivalent of Sissy Hankshaw's much-maligned digits in Tom Robbins's satirical novel *Even Cowgirls Get the Blues* (1976)—pulling back its hammer. A cartridge belt full of bullets circles his waist. Outfitted in fringed buckskins and a beaded headband with a gigantic teal-blue feather, his face painted in bright turquoise and green patterns and his black hair neatly coifed in a single braid, the Indian clenches an enormous red longbow in his hand—and keeps his Bowie knife tucked in his leather belt. Despite their abundant firepower, both characters are terrible marksmen: bullets, accompanied by a little puff of purple smoke, fly erratically overhead or through the Indian's feather; likewise, arrows pierce the cowboy's hat but are mostly suspended in the air above him.

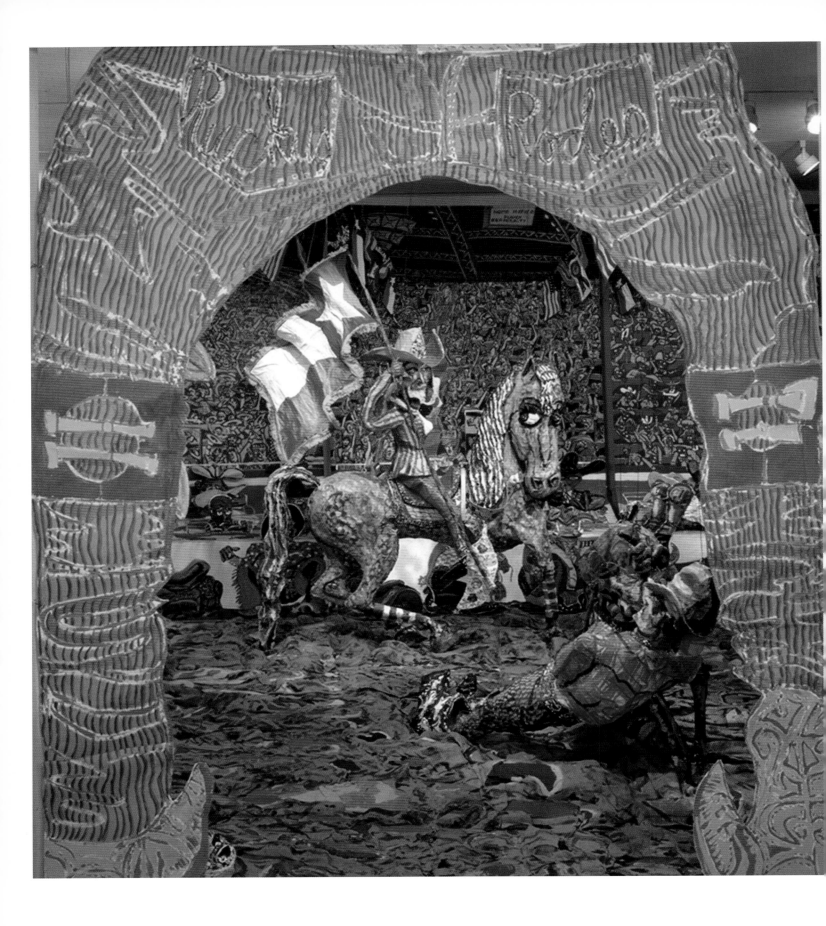

FACING PAGE:
RED GROOMS
Ruckus Rodeo (detail), 1975–76
Mixed-media installation, 174 x 606 x 294
Courtesy of the Modern Art Museum
of Fort Worth, Museum purchase
and Commission with funds from the
National Endowment for the Arts and
The Benjamin J. Tillar Memorial Trust,
and ©2007 Red Grooms/Artist Rights
Society (ARS), New York

[7]David Lusted, *The Western* (New York: Longman Publishing, 2003), 263.

8. Max Price, "Pop Artist Pops in on Denver," *The Denver Post*, October 22, 1985, sec. B.

9. According to museum staff, John DeAndrea's hyperrealistic sculpture *Linda* (1983) is the museum's most popular piece.

It's hard to figure out what these two iconic Western American types who are obviously disinterested in serious harm are fighting over: the space between them literally amounts to a few inches of nothing. And that's the point: as bad shots with pointless objectives, Grooms's cowboy and Indian duo is clearly a caricature. *Shoot-out* is a sculptural comedy starring two easily recognizable characters in one of America's longest-running melodramas; it is also a critical query about their abiding presence, and meaning, in the national narrative. Their exaggerated actions appropriate the clichéd exploits of any number of western American narratives, from nineteenth-century dime novels and illustrated newspaper serials to twentieth-century TV westerns. Their colorful outfits mimic the kinds of flashy getups featured in Wild West shows, rodeos, and Hollywood movies and further popularized as "western wear" play clothes for modern American children. In fact, *Shoot-out*'s detailed but slapdash style resembles, albeit on a much bigger scale, the sorts of roughly painted cardboard cutouts that stores like Sears used to promote Roy Rogers Double R Brand cowboy boots and kids' clothes in the 1950s.

Yet *Shoot-out* is also humorously and self-consciously at odds with these western American tropes. Like Robert Altman's 1976 movie *Buffalo Bill and the Indians, or Sitting Bull's History Lesson*, a riotous satire that rebukes much of the western American imaginary (and its sustained appeal at the moment of the nation's bicentennial), *Shoot-out* is oriented toward exposing "the ideological work of illusion and myth" in the genre of western American art.[7] As Grooms relates, *Shoot-out* "was really meant as a whimsical piece, showing how ludicrous the past cliché of cowboy-Indian relations is compared with the modern perception."[8] Interestingly, *Shoot-out* is the second most requested postcard among the Denver Art Museum's collection, suggesting that Grooms's revisionist critique of the western American "cliché" is both popularly understood and welcome.[9]

Born in 1937 in Nashville, Grooms grew up at a time when the western was still a dominant theme in American popular culture. Post–World War II newsstands carried hundreds of pulp magazines like *All-Western*, *Best Westerns*, *Exciting Western*, and *Six-Gun Western*; Americans of all ages avidly consumed cowboy comic books like *Roy Rogers Comics* and *Red Ryder Comics*; cheap paperbacks like Louis L'Amour's *Hondo* (1953) were

ROY ROGERS WITH
MEMORABILIA, CA. 1953
Courtesy of The Roy Rogers–Dale Evans
Museum

bestsellers; and in 1950 alone, Hollywood released more than 130 western movies, including classics like *The Gunfighter* (with Gregory Peck playing notorious gunslinger Jimmy Ringo), *Winchester '73*, *Broken Arrow*, and B-movie oaters like *Indian Territory* and *Beyond the Purple Hills* (both starring singing cowboy Gene Autry and Champion, "The World's Wonder Horse").[10]

Always attuned to the popular touchstones of Americana, Grooms has worked with western subjects throughout his career: *Western Pals* (1966) is a two-panel painting of motion picture cowboy Tom Mix making eyes at his superstar horse Tony; *The Great Western Act* (1971) depicts a toothy rope-twirling rodeo showman lassoing a high-stepping cowgirl; and the mixed-media installation *Ruckus Rodeo* features more than a dozen hard-charging buckaroos, a busty blonde rodeo queen astride a prancing Palomino, a gigantic sixteen-foot Brahma bull with six-foot-wide horns, and a few cartoony cowboy clowns—all performing in a packed arena surrounded by a roaring crowd of spectators.[11]

Shoot-out extends Grooms's satirical, if affectionate, swipe at western American archetypes. In spring 1979, while a visiting artist at the University of New Mexico, Grooms worked on a series of small, tabletop-size cast bronze sculptures featuring Indian subjects, including *Indian and Pickup Truck*, *Photographer and Indian (Wagon Piece)*, *Western Eagle*, and *Shoot-out*. (In 1980, these sculptures were exhibited at New York's Marlborough Gallery, where Donald Todd selected *Shoot-out* to be vastly enlarged as an outdoor public art piece.) During his stay in Albuquerque, Grooms met Fritz Scholder, a Luiseño Indian and an expressionist/pop art painter well known for his ironic portraits of Native Americans. Scholder encouraged him to tackle the theme of Indian stereotypes and the general "kitschification" of indigenous cultures; as Grooms later explained, Scholder "was one of the reasons I did it [*Shoot-out*] because I was really excited about Indian art . . . They had this different vein of subject matter than in the East."[12]

In the 1970s, southwestern Indian artists such as Scholder and T. C. Cannon repeatedly challenged clichéd representations of native peoples, as well as limiting assumptions of "authentic" Indian art styles and the tackier aspects of "Indian country" tourism, in a series of edgy pop art paintings. Scholder's *Super Indian #2* (1972), for example, features a ceremonial dancer outfitted in a huge buffalo headdress, taking a break from cultural tourism while sitting on a sidewalk curb with a strawberry ice cream cone. Interrogating both the myth of the noble savage and the so-called "traditional" style of southwestern Indian painting, Scholder called his anti-heroic images "monster Indians" and painted his subjects in broad, brushy strokes and loud, neon hues indebted to artists like Francis Bacon, Leonard Baskin, and Wayne Thiebaud (with whom Scholder studied in the late 1950s).[13] Likewise, Cannon's *Collector #5* (1975), one of a series of psychologically charged portraits of American Indians that questioned assumptions of modernity and identity, depicts a nineteenth-century Pawnee chief in tribal clothing, sitting on a white wicker chair in a living room parlor decorated with a Navajo rug and a print of Vincent van Gogh's 1890 painting *Wheat Field with Crows*. Similarly aimed at deconstructing ethnic, racial, and aesthetic stereotypes and at testing the boundaries between art and popular

10. John G. Cawelti, *The Six-Gun Mystique Sequel* (Bowling Green, OH: Bowling Green State University Popular Press, 1999), 190–94; William W. Savage Jr., *Commies, Cowboys, and Jungle Queens: Comic Books and America, 1945–1954* (Hanover, NH: Wesleyan University Press and University Press of New England, 1998), 66–73; and R. Philip Loy, *Westerns in a Changing America, 1955–2000* (Jefferson, NC: McFarland & Company, Inc., 2004), 7.

11. Grooms also produced *Western Pals* as a color lithograph in 1997.

12. Irene Clurman, "Eye on Art: Grooms' *Shoot-Out* a Rib-tickling Sculpture," *Rocky Mountain News*, September 10, 1982, sec. W.

13. See, for example, W. Jackson Rushing, "Authenticity and Subjectivity in Post-War Painting: Concerning Herrera, Scholder, and Cannon," in *Shared Visions: Native American Painters and Sculptors in the Twentieth Century*, eds. Margaret Archuleta and Rennard Strickland (Phoenix: The Heard Museum, 1991), 12–21; Scholder quoted on p. 17. See also Scholder's book *Indian Kitsch: The Use and Misuse of Indian Images* (Flagstaff, AZ: Northland Press, 1979).

14. Jane Comstock, "Not Funny: The Failure of Red Grooms' *Shoot-out* as Public Sculpture" (seminar paper, University of Kansas, November 1994), copy in *Shoot-out* files, Denver Art Museum. In 1982, Grooms told reporter Irene Clurman that he had considered doing a work showing himself shaking hands with Scholder as "a new version of east-meets-west" (Clurman, "Grooms' *Shoot-out* a Rib-tickling Sculpture," [see n. 12]).

RED GROOMS
Western Pals, 1997
Color lithograph, Edition 40, 8.5 x 12.5
Courtesy of Shark's Ink, Lyons, CO, and ©
Red Grooms/Artist Rights Society (ARS),
New York

15. Erika Doss, "Hangin' Out at the Leanin' Tree: Mastery and Mythos in Western American Art, Old and New," *Journal of the West* 40, no. 4 (Fall 2001): 16–25.

culture, Grooms's *Shoot-out* is clearly indebted to such satirical, and subversive, work. Indeed, art world lore in Denver has it that *Shoot-out*'s red-haired, bulbous-nosed cowboy is Grooms himself, while the Indian is a portrait of Scholder.[14]

Humor is often present in western American art, which is intriguing given the genre's general popularity. Speaking very broadly, western American art has been persistently geared toward mass audience expectations and hence exceptionally attuned to the often mercurial dynamics of popular taste and tolerance. Expectations remain, for example, that western American art stay within the stylistic boundaries of realistic representation (or pseudodocumentary illustration) and that it narrate a frontier imaginary of heroic action, masculine adventure, unspoiled nature, and exotic natives.[15] When it does not, when as in the case of *Shoot-out* those popular expectations are contested, public controversy and critical condemnation may ensue. Yet throughout its history and development, western American art (like American art in general) has wrestled with itself, largely because there has never been a static, or shared, sense of what the West (like America) actually is, or represents. As a result, more than a few western American artists have chafed against various expectations of the genre and have repeatedly tested them, along with the "frontier mythos" of the West itself. Simultaneously creating and subverting its own sensibility as a subject, a style, and a popular vehicle of ideological persuasion, select examples of western American art display a cunning self-consciousness, suggesting a keen awareness of the genre's significant role in shaping and directing the national narrative and yet also playing against those expectations.

T.C. CANNON

Collector #5, 1975

Oil and acrylic on canvas, 72 x 60

Courtesy of the T.C. Cannon Estate

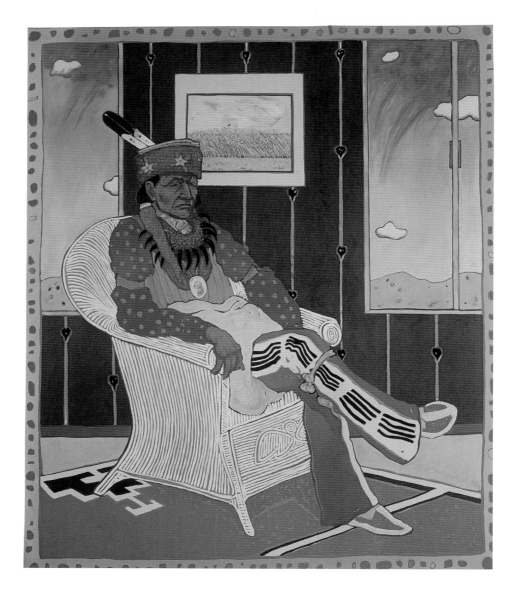

The issue of western American art's popularity is central to the genre's "emergence as a legitimate scholarly subject."[16] Fundamental to this project is recognition of the complicated and often conflicted interplay among various visual cultures, as well as a heightened criticality regarding issues of representation, identity, and modernity. Western American art's popularity hinges on both the centrality, however elusive, of the "West" in the national imagination and on the enormous mass media efforts that were made, especially in the nineteenth century, to forge public enthusiasm for western subjects. The first American dime novel, for example, a genre claimed by some scholars as the first truly American form of popular culture, was Ann Stephens's *Malaeska: The Indian Wife of the White Hunter*. Published by New York's Beadle and Company in June 1860, *Malaeska* quickly sold some 300,000 copies. Capitalizing on the success of this "frontier narrative" (actually set in colonial New York), Beadle rushed to release other dime novels, including

16. Joni L. Kinsey, "Viewing the West: The Popular Culture of American Western Painting," in *Wanted Dead or Alive: The American West in Popular Culture*, ed. Richard Aguila (Urbana: University of Illinois Press, 1996), 244.

17. Daryl Jones, *The Dime Novel Western* (Bowling Green, OH: Popular Press, 1978), 8; Shelley Streeby, *American Sensations: Class, Empire, and the Production of Popular Culture* (Berkeley: University of California Press, 2002), 223–24; Christine Bold, "*Malaeska's* Revenge: The Dime Novel Tradition in Popular Fiction," in Aguila, *Wanted Dead or Alive*, 21–42; and Jane Tomkins, *West of Everything: The Inner Life of Westerns* (New York: Oxford University Press, 1994), 42 and passim. *Malaeska* was actually written in 1839 for *The Ladies Companion* and was rereleased by Beadle in 1860.

18. Joni L. Kinsey, *Thomas Moran's West: Chromolithography, High Art, and Popular Taste* (Lawrence: University Press of Kansas, 2006), 58.

19. Peter H. Hassrick, "The Elements of Western Art," in *The American West: Out of Myth, Into Reality* (Washington, DC: Trust for Museum Exhibitions, 2000), 24 and passim.

20. William H. Goetzmann and William N. Goetzmann, *The West of the Imagination* (New York: W. W. Norton & Company, 1986), 121. In addition to *The Stagecoach*, Rockwell painted twenty oil portraits of the movie's ten stars. He also had a bit part in *Stagecoach* as the character "Busted Flush."

COVER, BEADLE'S HALF DIME LIBRARY 10, NO. 254 (JUNE 6, 1882). Courtesy of the Department of Special Collections, Stanford University Libraries

Stagecoach movie poster, 41 x 27

THEODORE DAVIS

On the Plains—Indians Attacking Butterfield's Overland Dispatch Coach, (from *Harper's Weekly,* April 21, 1866) Wood engraving, 10.5 x 15.5 Collection of Mississippi Museum of Art, Jackson, Miss., Purchase, 1999.023a-b

Edward S. Ellis's *Seth Jones: or, the Captives of the Frontier* (published in October 1860). This dime novel sold even more copies (over 600,000) and basically set the stage for the post–Civil War dominance (in publishing but also in the larger public/political imagination) of heroic male-centered narratives of the American West.[17]

The images accompanying these bestselling pulps surely enhanced their popular appeal: however hackneyed, the cover illustration of Ellis's 1882 *The Half-Blood; or, The Panther of the Plains*, a wood engraving featuring an angry Indian brandishing his bloodstained knife at a terrified white man bound to a tree, is dramatic and compelling. Such pictures reified the West as a dramatic frontier of mostly male, mostly white adventurers. Their vast numbers (Beadle alone published over 600 novels), along with multitudes of other nineteenth-century paintings, drawings, photographs, and chromolithographs, helped to generate and perpetuate these and other popular understandings of the West; as Joni Kinsey writes, "Visual images, as virtually no other medium could, helped make the place imaginable."[18]

Pictures such as Fanny Palmer's *The Rocky Mountains, Emigrants Crossing the Plains* (1866), Albert Bierstadt's *Oregon Trail* (1869), and John Gast's *American Progress* (1873) imagined the West on positive and progressive terms, celebrating Manifest Destiny as a seemingly simple exercise of forward-thrusting wagon trains.[19] Pictures like Carl Wimar's *The Attack on an Emigrant Train* (about 1856) imagined some of the dangers along the way. Wimar's painting, in fact, became the "master image for countless other Indian-attacks-on-wagon-train pictures" ranging from Theodore Davis's wood engraving *On the Plains: Indians Attacking Butterfield's Overland Dispatch Coach* (1866), produced for *Harper's Weekly*, to Norman Rockwell's *The Stagecoach* (1966), a movie poster produced for the Hollywood remake starring Bing Crosby, Ann-Margret, and Mike Connors.[20] Movies, the most popular medium of the twentieth century, continued to visually imagine the West on these terms for an ever-growing mass audience; indeed, the western was Hollywood's most popular motion picture subject well into the 1960s.

ON THE PLAINS—INDIANS ATTACKING BUTTERFIELD'S OVERLAND DISPATCH COACH.—SKETCHED BY THEODORE R. DAVIS.—[SEE PAGE 240.]

Here's how to me and my friends
the same to You and Yours

I savvy these folks

CHARLES RUSSELL
I Savvy These Folks, 1907
Watercolor and ink on paper,
7.75 x 11.875
Gilcrease Museum, Tulsa, OK.

FACING PAGE:
OSCAR BERNINGHAUS
Movie Night at Taos Theater, 1939
Oil on canvas, 30 x 40
Berninghaus Family Collection

If visual popularity helped to construct the West's meaning in the national imaginary, it also made it an extremely compelling subject for those American artists interested in exposing its contradictions and complexities. Some did so in a joking, folksy kind of way, as if reminding their audiences that western American subjects were neither as heroic nor ideal as they might assume. Charles Russell was especially gifted at tackling these perceptions, as his voluminous illustrated correspondence details. *I Savvy These Folks* (1907), for example, satirizes an entire cavalcade of western characters, from unshaven cowboys and cigar-smoking land speculators to blanket-draped Indians and the artist himself, smirking at his viewers as he salutes them with a bottle of booze. Even as he helped to construct the western mythos in highly popular paintings of cowboys and Indians, Russell contested it, and he was hardly alone. Walt Kuhn, who worked as a cartoonist for western newspapers like the San Francisco weekly *The Wasp* from 1899 to 1900 and helped organize the Armory Show in 1913, painted the West with a similar slapstick sensibility, poking fun at popular stereotypes of brawling cowboys, two-fisted gamblers, and loose saloon girls in his twenty-nine-panel series *An Imaginary History of the West* (1918–23).[21] Likewise, Oscar Berninghaus juxtaposed the expected and the unexpected in *Movie Night at Taos Theater* (1939), which depicts a sizeable and diverse Taos audience—Indians, Hispanics, Anglos—watching a small band of Indians attack a stagecoach in some B western. Dividing the painting into two sections, with a narrow, darkened strip at the bottom illustrating the movie theater audience and more than two-thirds of the canvas picturing the brilliantly illuminated and gigantic movie screen, Berninghaus reflected on western American image-making and the ideological power of popular culture.[22]

Red Grooms's *Shoot-out*, in other words, is backed by a long parade of western American artworks similarly engaged in myth-busting. Nor does artistic reckoning with the mythic West show signs of abating. In *Last of the Great Buffalo Hunters* (1987), for example, Robert Arneson satirized Jackson Pollock's self-promotion as an abstract expressionist cowboy from Cody (where Pollock was born in 1912) and raised questions about the "primitive" underpinnings of some of his paintings. In the early 1940s, Pollock produced a number of works that referenced Native American tropes such as skulls, totems, handprints, and serpents; as he remarked in 1944: "I have always been very impressed with the plastic qualities of American Indian art. The Indians have the true painter's approach in their capacity to get hold of appropriate images . . . Their color is essentially Western."[23] In 1949, Pollock received major media exposure in the pages of *Life* magazine, where his

21. Philip Rhys Adams, *Walt Kuhn, Painter: His Life and Work* (Columbus: Ohio State University Press, 1978), 74–77; and Michael Zakian, "New Visions of the West, 1905–1951," in *Transforming the Western Image in 20th Century American Art*, eds. Katherine Plake Hough and Michael Zakian (Palm Springs, CA: Palm Springs Desert Museum, 1992), 22.

22. Berninghaus's son-in-law was the co-owner of this Taos movie theater, which was built in 1939, and Berninghaus painted *Movie Night at Taos Theater* for him and his daughter; see Gordon E. Sanders, *Oscar E. Berninghaus, Taos, New Mexico: Master Painter of American Indians and the Frontier West* (Taos, NM: Taos Heritage Publishing Company, 1985), 88.

23. Jackson Pollock quoted in answers to a questionnaire in *Arts and Architecture* 61 (February 1944): 14; and Stephen Polcari, *Abstract Expressionism and the Modern Experience* (Cambridge: Cambridge University Press, 1991), 239.

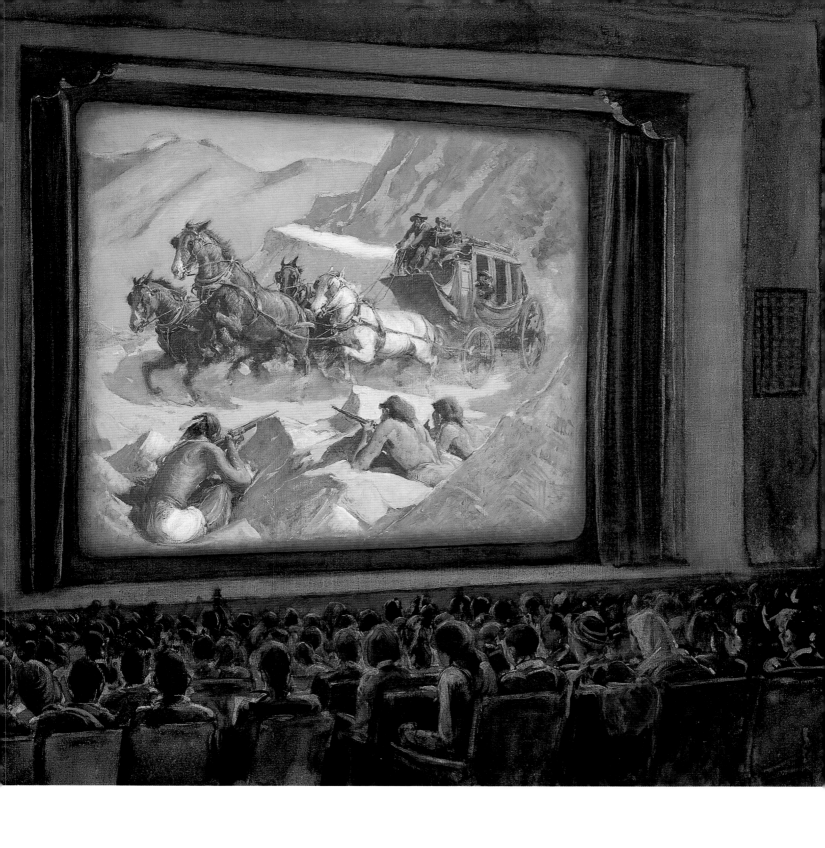

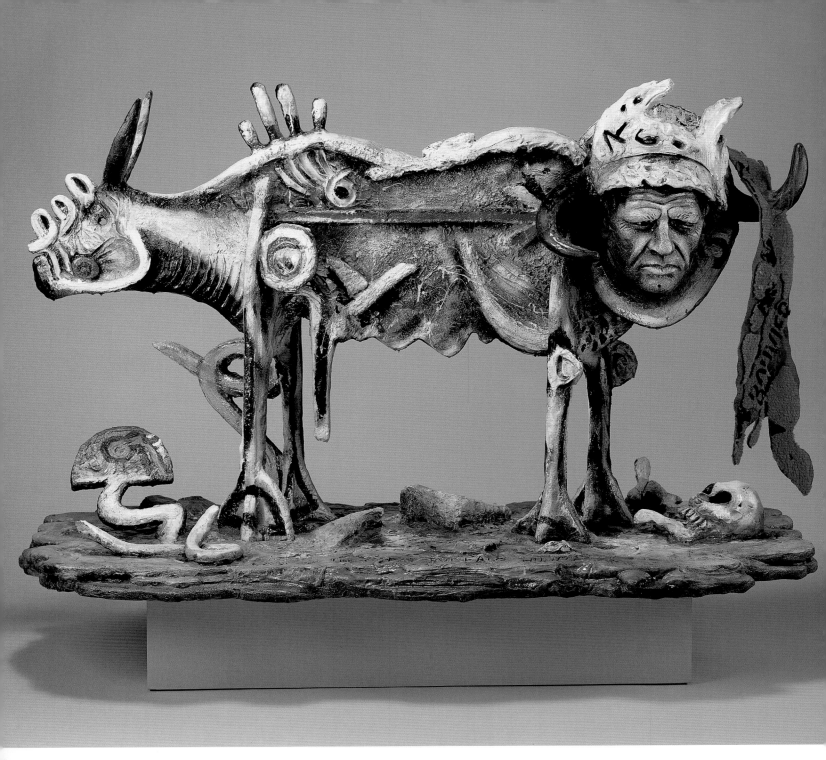

ROBERT ARNESON
Last of the Great Buffalo Hunters, 1987
Wood, fixall, ceramic, paint, leather,
57 x 74 x 32
Denver Art Museum, Funds from the
Colorado Contemporary Collectors and
the National Endowment for the Arts
Art © Estate of Robert Arneson/Licensed
by VAGA, New York, NY

24. "Jackson Pollock," *Life*, August 8, 1949, 42–45.

25. Philip J. Deloria, *Indians in Unexpected Places* (Lawrence: University Press of Kansas, 2004), 4; Ratcliff, *Red Grooms*, 238.

RED GROOMS
Shoot-out, 1982
Painted aluminum, 166.5 x 142.75 x 297.25
Denver Art Museum, Gift of Lawrence
Street Ventures and ©Red Grooms/Artist
Rights Society (ARS), New York

laconic image as a cigarette-smoking, blue-jean-wearing cowboy–action painter largely set the standard for postwar artistic identity.[24] Mounting a portrait of Pollock in a buffalo headdress onto the rear end of a ceramic sculpture replicating his 1943 painting *The She-Wolf*, Arneson mocked Pollock's essentialist assumptions about Native American art and made fun of art world stereotypes about the American West in general.

Humor, of course, hinges on "broad cultural expectations [that] are both the products and the tools of domination," writes Phil Deloria in his analysis of Native American stereotypes and their impact on the shape and direction of the standard western American narrative. Central to the project of western American art is to similarly recognize the "malice and misunderstanding" inherent in the popular-culture stereotypes on which much of the art rests: to contextualize their origins and intentions, to question their assumptions, and to refuse their repetition. As Grooms explains: "I think satire can heal old wounds, and that was my intention with *Shoot-out*. I had hoped that some sense of a positive partnership for the future would come out of a burlesque depiction of two interlocking former foes."[25] Today, his sculpture may well do exactly that: in spring 2006, *Shoot-out* was moved again, this time to a prominent deckside position outside the Duncan Pavilion, part of the Denver Art Museum's newly expanded complex.

Photography
and the Western Scene

Martha A. Sandweiss

1. For a suggestion of what seemed to constitute a distinctively "western" photography, see Karen Current, *Photography and the Old West* (New York: H. N. Abrams, 1978), with its focus on photographs of cowboys, Indians, pioneer settlers, and western landscapes.

All images where noted are from the collection of the Denver Art Museum, Daniel Wolf Landscape Photography Collection, Funds from Mr. and Mrs. George G. Anderman, Nancy L. Benson, Florence R. and Ralph L. Burgess Trust, 1990 Collectors' Choice, J. Rathbone Falck, General Service Foundation, Mr. and Mrs. William D. Hewit, Mr. and Mrs. Edward H. Leede, Pauline A. and George R. Morrison Trust, Jan and Frederick Mayer, Newmont Mining Corporation, O'Shaughnessy Fund, Volunteer Endowment Fund, Ginny Williams, Estelle Wolf, anonymous donors, and the generosity of our visitors, with additional support from the voters who created the Scientific and Cultural Facilities District.

FACING PAGE:

ALEXANDER GARDNER

Big Mouth Arapaho, ca. 1875

Photograph, 6.5 x 5.125

Denver Art Museum, The Daniel Wolf Landscape Photography Collection

Photography came late to the world of western American art. Well before photographers ever accompanied explorers into the mountains of the West or set up commercial studios in the region's nascent cities, painters established the general parameters of the genre. It would be figurative in style, narrative in purpose, and focused on subjects that seemed distinctively (and recognizably) western. The photographs we've come to embrace as western largely follow suit.[1] But for all its seeming realism, western photography, like western painting, has always drawn from and contributed to more abstract cultural and political arguments about the inevitability of the United States' westward expansion, the demise of indigenous cultures, and the centrality of the western landscape to the national sense of self. As a medium with a message, western photography has long responded to popular taste even as it helped to shape it.

Following its invention in France in 1839, photography spread slowly into the American West. During the two decades preceding the Civil War, most commercial photographers in the region settled in population centers where a steady supply of portrait clients offered some prospect of financial success. Most early photographs made in the American West are thus studio portraits that, lacking any distinctively western accouterments, look similar to photographs made anywhere else in the country. Despite their place of origin, we rarely think of them as examples of a distinctively "western" photography. A nineteenth-century photograph of a man wearing cowboy chaps, for example, or a portrait of a Native American in a headdress, might claim our attention as "western," but a contemporary studio photograph of a white child does not, despite the fact that Euro-American town dwellers far outnumbered cowboys or Indians in the late-nineteenth-century West. From the start, notions of "westernness" developed in other media —from painting to literature to popular culture—predetermined viewers' perceptions of what constituted westernness in a photograph. It hinged less on where the picture was made than on what it seemed to show.

Not surprisingly, then, nineteenth-century western photographers found their most distinctive and recognizably western subject in the physical landscape. One might visually mistake a San Francisco studio portrait for one made in Cleveland or Boston, but no one could confuse the peaks of Yosemite or the central Rockies with any geographical sites east of the Mississippi. Moreover, a landscape photographer could claim the authority of the eyewitness observer. Frederic Remington might be able to conjure up pictures of the West in his New Rochelle, New York, studio, but no landscape photographer (at least in the era before digital imagery) could pull off a similar trick. Photographers could claim as a matter of course the kind of verisimilitude that western painters had to work so hard to create.

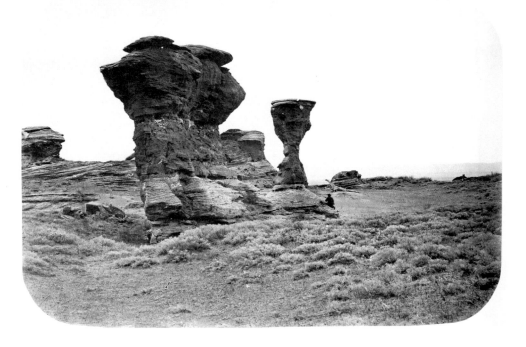

EADWEARD MUYBRIDGE
*Looking Down Yosemite Valley, No. 53,
ca.* 1870
Albumen print, 6.5 x 8.75
Denver Art Museum, The Daniel Wolf
Landscape Photography Collection

ANDREW JOSEPH RUSSELL
Dial Rock, Red Buttes, 1869
Albumen print, 8.5 x 11.75
Denver Art Museum, The Daniel Wolf
Landscape Photography Collection

 Initially, during the 1840s and '50s when daguerreotypy prevailed as the main technology for photographic image making, few western landscape photographers met with much success.[2] Daguerreotypes were small, unique images on silver-coated copper plates, made without negatives. Their size and reflective surface made them difficult to view or reproduce, and they could not rival the visual pull of landscape paintings that employed color, scale, and invented narrative details to draw in the viewer. But during the 1860s, in the immediate aftermath of the Civil War, western landscape photographers hit their stride. Employing the laborious new wet-plate negative technology that enabled them to use glass negatives to make larger and more easily reproduced images on paper, commercial photographers like San Franciscans Carleton E. Watkins and Eadweard Muybridge discovered that a long and difficult trip to, say, Yosemite, could pay off in

2. An expanded discussion of this point can be found in Martha A. Sandweiss, *Print the Legend: Photography and the American West* (New Haven, CT: Yale University Press, 2002).

3. James N. Wood in Weston J. Naef, *Era of Exploration: The Rise of Landscape Photography in the American West, 1860–1885,* in collaboration with James N. Wood, (Buffalo, NY: Albright-Knox Art Gallery in association with New York Graphic Society, 1975), 130.

terms of commercial sales. From a single hard-won negative, they could make multiple saleable prints. The federal exploring expeditions sent west to map the region in the late 1860s and '70s employed photographers as a matter of course, and these artists—Watkins, Timothy O'Sullivan, William Bell, William Henry Jackson, and John K. Hillers—produced landscapes we now value as iconic images of the nineteenth-century West. Their contemporaries documenting the construction of the western railroad lines, including A. J. Russell and Alexander Gardner, likewise made widely distributed images that touted the wonders of the western landscape and provided Americans with a glimpse of a world few had seen for themselves.

These western landscapes had reportorial value: they seemed to show what the West *looked* like. But they came laden with cultural meanings, as well, conveyed through a selective choice of subject matter, through the sequencing of views, and through the narrative words so often printed on the photographs and photographic mounts themselves. Consider, for example, the striking landscape views that Timothy O'Sullivan made during the survey seasons of 1871, 1873, and 1874, while employed as the photographer for Lt. George Montague Wheeler's military exploring survey of the lands west of the hundredth meridian. As modern-day viewers we might read them in any number of ways—as studies in abstract form, as expressions of the sublime, or conversely (as one art historian puts it) as compositions in which "man is presented as cerebral and reflective in the face of nature, an unobtrusive presence rather than a vehicle for dramatizing a confrontation with the sublime."[3] But the landscapes entered the visual marketplace with very specific meanings. Captions in the albums in which the photographs originally appeared clarified that O'Sullivan's extraordinary photographs of Black Canyon on the Colorado River were meant

TIMOTHY H. O'SULLIVAN

Black Canon, Colorado River, From Camp 8, Looking Above, 1871

Albumen silver print 8 x 20

Denver Art Museum, The Daniel Wolf Landscape Photography Collection

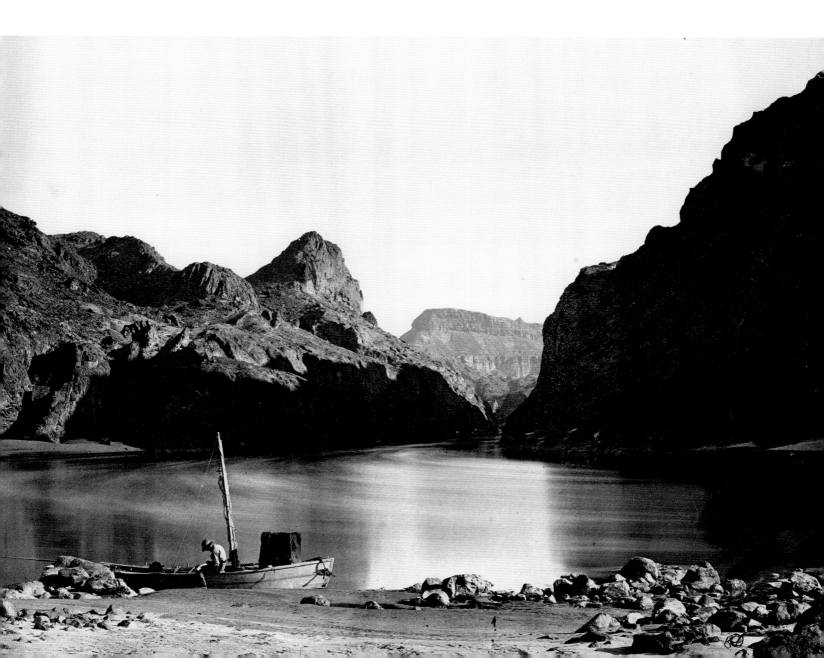

TIMOTHY H. O'SULLIVAN
Cooley's Park, Sierra Blanca Range,
Arizona, 1873
Albumen silver print, 8 x 10.75
Denver Art Museum, The Daniel Wolf
Landscape Photography Collection

TIMOTHY H. O'SULLIVAN
Snake River Canon, Idaho, View From
Above Shoshone, 1874
Albumen silver print, 7.875 x 10.875
Denver Art Museum, The Daniel Wolf
Landscape Photography Collection

4. See the descriptive texts published
in the Wheeler survey album included
in the collection of the Beinecke Rare
Book and Manuscript Library, Yale
University. War Department, Corps
of Engineers, U.S. Army, *Photographs*
Showing Landscapes, Geological
and Other Features, of Portions of
the Western Territory of the United
States. Obtained in Conjunction
with Geographical and Geological
Explorations and Surveys, West of the
One Hundredth Meridian, Seasons
of 1871, 1872, 1873, 1874, First
Lieutenant Geo. M. Wheeler, Corps of
Engineers, U.S. Army in Charge (n.p.,
[ca. 1874]). The O'Sullivan prints in
the Denver Art Museum collection
are identical to prints in the Beinecke
album and may originally have come
from a similar bound volume.

5. Howard Bossen, "A Tall Tale Retold:
The Influence of the Photographs of
William Henry Jackson on the Passage
of the Yellowstone Park Act of 1872,"
Studies in Visual Communications
8, no. 1 (Winter 1982): 98–109. For
examples of the Jackson collages,
some of which were reproduced in the
booklets of western scenes compiled
by William Crane in the 1910s and
1920s, see Carol E. Roark, Paula Ann
Stewart, and Mary Kennedy McCabe,
Catalogue of the Amon Carter Museum
Photography Collection (Fort Worth,
TX: Amon Carter Museum, 1993),
333–38.

6. L. A. Huffman, "The Huffman
Pictures" (brochure, n.d., Photography
Collection, Montana Historical
Society). See also Sandweiss, *Print the*
Legend, 335–37.

to illustrate the tremendous difficulties of western exploration and the heroism of those who
survived the "arduous and hazardous" work of laying the path for American civilization.
An unpopulated landscape of Cooley's Park in the Sierra Blanca Range of Arizona offered
proof that the "hostile Apaches" had been subjugated and confined to reservations where
they were being "instructed in the various arts of peaceful self-support." A view of Shoshone
Falls in the Snake River Canyon of Idaho not only illustrated the potential of the site as a
"summer resort for the tourist and artist" but gave evidence of the nation's natural blessings.
Just out of sight of the viewer, a caption explained, lay a magnificent bald eagle's nest and
gold diggings miraculously renewed "by the agency of the river."[4]

Nineteenth-century landscape photographs—and their attendant captions—
conveyed contradictory messages about the West. On the one hand, the West had vast
wilderness areas of stunning beauty that reinforced a faith in American exceptionalism,
offered Americans a kind of spiritual touchstone for the renewal of the national spirit,
and affirmed the virtue of the expansionist enterprise. But America's sense of self-worth
simultaneously depended on the national ability to transform that wilderness—by banishing

Indians, laying roads across the trackless landscape, and exploiting the region's natural resources. To a nineteenth-century eye, there seemed little unsightly about an open mine or a deforested hillside. An industrial landscape could seem as central to the American enterprise as a wilderness view. And indeed, photographers depicted industrial landscapes more often than painters did, in part because they more often worked for patrons (and served local buyers) who had a financial stake in the development of natural resources.

Virtually all nineteenth-century western photographers thought of themselves as businessmen rather than artists. And unlike painters, they made money not by selling one picture for a large sum to a single buyer but by selling multiple copies of an image to a great many customers. Their success generally depended on their ability to make pictures with mass appeal. A photograph might be valued because it described something new and unfamiliar. But it might just as easily achieve value because it reaffirmed a popular idea. In 1871, for example, William Henry Jackson made some of the first photographs of the Yellowstone country, widely praised pictures that helped persuade Congress to set the area aside as a national park. Later in his career, however, he produced photographic "paste-ups," collages made from different photographic prints that conveyed a more idealized image of a West viewers wanted to see.[5]

A sense of irony about the alteration of the natural landscape, doubt over the moral imperative of westward expansion, regret over the United States' treatment of the West's Hispanic, Indian, or Chinese inhabitants; such ideas are largely absent from the photographic documentation of the nineteenth-century West, largely because they would have had no commercial appeal. Few nineteenth-century professional photographers worked without an eye on the marketplace. The invention of dry-plate negatives brought more amateurs to the field of photography in the 1880s, but until the advent of the easy-to-use Kodak snapshot cameras around 1890, western photography remained a largely professional, and hence commercial, undertaking in which success depended upon catering to the desires and needs of patrons. Because of its relatively low cost, reproducibility, and utility as a promotional tool, photography has always been more exquisitely sensitive to popular taste than painting.

At the very end of the nineteenth century, the central theme of western photography shifted. Once a medium that spoke powerfully to the West that *would be*, it became a medium more concerned with the West that *had been*, as if all the West's distinctiveness lay in its past. During the 1860s, the railroad photographer Alexander Gardner titled several of his views *Westward the Course of Empire Takes Its Way*, words that seemed to symbolize the spirit of the age. By 1904, however, Edward S. Curtis's photograph *The Vanishing Race*, a picture of Navajo riders on horseback disappearing into the darkness of what Curtis called "an unknown future," more aptly suggested the prevailing concern of western photographers. Their subject was the past; not simply an Indian past, but that long historical moment when the West seemed definably different from the rest of the nation. In 1898, the Montana cowboy photographer Laton Huffman published a catalog of his work, promising buyers a glimpse of a "chapter forever closed." His pictures told a story, he said, "that, as time goes on, grows more interesting."[6]

With the passage of time, however, nineteenth-century western photographs—particularly landscape photographs—lost their ability to convey these larger stories about American progress or collective nostalgia and came to be valued for other reasons. In 1937, curator Beaumont Newhall included the work of some of the western landscape photographers in his centennial survey of the history of photography at the Museum of

EDWARD S. CURTIS

The Vanishing Race, Navaho, 1904

Platinum print, 16 x 20.75

Denver Art Museum, The Daniel Wolf

Landscape Photography Collection

Modern Art, and in 1940 photographer Ansel Adams included the "exciting work of the great western photographers, such as Jackson, O'Sullivan and Watkins" in his *Pageant of Photography* exhibition at the Golden Gate Exposition in San Francisco. "The work of these hardy and direct [western] artists indicates the beauty and effectiveness of the straight photographic approach," Adams wrote. "No time or energy was available for inessentials in visualization or completion of their pictures. Their work has become one of the great traditions of photography."[7]

 Western landscape photography thus came to be valued for its aesthetic style. On the one hand, this led to its embrace as a distinctively *American* form of photography, and western photography thus escaped the fate of so much western painting, long excluded from the central narrative of American art. But this reassessment of nineteenth-century photographs had two other consequences as well. It effectively erased the pro-development agenda of most western landscape photography and simultaneously reified a particular sort of landscape—the large, majestic wilderness view—as the defining idiom of the genre. Hence, Edward Weston's close-up pictures of rocks and trees along the Carmel, California, coast came to be embraced as modernist evocations of sharply observed forms, while Ansel Adams's sweeping landscapes of the high Sierras came to be understood as more regionally "western," less about form than place.

 In celebrating the aesthetics of nineteenth-century landscape photographs rather than the complicated politics that underlay their construction, twentieth-century curators like Newhall and Adams obscured the particular historical context in which the pictures had first appeared. By and large, these photographs had been made to hang in railroad stations, not art museums, and were intended to persuade investors, not comfort collectors. Revalued as art, they lost their political punch. And thus Adams and his contemporary, the color photographer Eliot Porter, came to seem the mid-twentieth-century inheritors of the great western photographic tradition, despite the fact that they were both ardent conservationists. In their photographs, their photographic books, and their various alliances with the Sierra Club, they each drew attention to the western landscape as something wild and untouched by human beings and deserving of preservation. Their popularity helped erase the fact that their nineteenth-century predecessors actually worked as agents of the government forces and private corporations that sought to develop the western landscape.

7. Ansel Adams, introduction to *Pageant of Photography,* exhibition catalog (San Francisco: Crocker-Union, 1940).

FACING PAGE:

ANSEL ADAMS

Clearing Winter Storm, 1944

Gelatin silver print, 22.125 x 28.125

Denver Art Museum, General Services

Foundation Purchase Fund

Collection Center for Creative

Photography, University of Arizona

© The Ansel Adams Publishing Rights

Trust

In their different ways, though, the nineteenth-century survey photographs and the twentieth-century western landscapes by photographers like Adams and Porter made a similar point about life in the American West. The physical landscape existed as something apart from human culture. It might be subdued by technology, despoiled by careless intruders, or saved through thoughtful preservation, but it could still be encountered in a fundamentally pristine state. This way of thinking erased the older Indian history of the region and underscored the idea that the key dynamic of western American history lay in the physical encounter between Euro-Americans and the environment. The landscape photographs valorized as particularly "western" thus reinforced Frederick Jackson Turner's oft-cited (and oft-criticized) remarks about the importance of the frontier in American culture. It was not the interactions between and among peoples that shaped the West, but the physical challenge of life in a harsh frontier environment that produced a distinctly regional culture.

Turner, writing in 1893, had to look back to a period of frontiering to locate a distinctive form of western American culture, and his sense that this particular phase of history was over shaped generations of subsequent historical writing and thought. Photographers at the very end of the nineteenth century likewise looked backward for subjects to express the essence of western regionalism. And just as Turner could not quite imagine how the West could preserve a distinctive identity in an increasingly urban, post-frontier era, western photographers in the early and mid-twentieth century likewise found it hard to convey an image of distinctive regionalism without reverting to older visual idioms.

Thus, photographs made in the West that failed to echo the subject matter and style of nineteenth-century images—especially portraits of Indians and pictures of the western landscape—came to seem outside the canon of western photography. Pictures documenting the interactions among western peoples or the rhythms of western urban life, for example, even when made in the sort of sharp, straight-focus style celebrated by nineteenth-century landscape photographs, found scant place within the genre. When the Bay Area photographer Dorothea Lange documented the urban breadlines that grew up near her home during the Great Depression, she found recognition not as a western photographer but as a social documentarian. Similarly, when David Hockney experimented in the 1970s with photographic collages of such distinctively western sites as Yosemite or Zion Canyon, critics more readily cited the works' connections to cubism than to western photography. Style as well as content circumscribed the canon.

Subject matter and aesthetic form, both constrained by the conventions of earlier nineteenth-century examples, still define the parameters of western photography and limit the genre's ability to convey a complex critique of regional culture. Richard Avedon intended his large-format portraits of westerners, executed for an exhibition and book, *In the American West* (1985), to evoke the work of earlier western photographers and to provide an unsparing glimpse of western life during the energy bust of the early 1980s. But by hewing close to the conventions of the genre, focusing on subjects with distinctively rural western jobs and identities, and largely avoiding any allusion to the West as an urban region tied into the world economy, he simply gave a modern twist to an old nineteenth-century stereotype of western American life.[8] Western photography provides the model of a grand tradition, but its boundaries—particularly with regard to the social landscape—can prove confining.

Some of the most vibrant and interesting contemporary western American photography comes from photographers who acknowledge the genre's fixed subject matter and stylistic conventions even as they gently tweak them. Working with the distant vistas favored by his nineteenth-century predecessors, Robert Adams pictures the suburban sprawl spreading across the mountain West, the tiny houses stretching to the horizons an ironic comment on the ambitions of earlier explorers, industrialists, and photographers. Richard Misrach plays with the expansive beauty of the nineteenth-century view, making glowing color landscapes of western bombing ranges, for example, that invert the old idea of the West as a site of infinite possibilities. Mark Klett rephotographs the sites captured by nineteenth-century landscape photographers, making pictures that disrupt the old progressive idea that history inevitably moves in a single direction. In his photographs, empty vistas become populated landscapes, but old mining towns likewise decay back into seeming wilderness. In pictures such as these, western photography proves itself to be a more elastic genre than western painting. It may remain rooted in sharply focused images of recognizably western people and places, but it is not immune to humor, irony, introspective self-reflection, or distinctively modern ideas about growth and development.[9]

As long as the genre of western photography remains rooted not just in a particular style but in a set of circumscribed topics, however, it will have a problematic relationship to western life as well as to the larger art market. If we continue to imagine that "western" photography must deal with the unpopulated and recognizably western landscape or with people who by virtue of their ethnicity or profession seem descendants of nineteenth-century western types, the genre cannot possibly address the complexity of contemporary life in the western United States. Unless the genre can somehow embrace an expanded set of subject

8. Richard Avedon, *In the American West* (New York: Harry N. Abrams, Inc., 1985).

9. See, for example: Robert Adams, *New Topographics: Photographs of a Man-Altered Landscape* (Rochester, NY: George Eastman House, 1975); Robert Adams, *The New West: Landscapes Along the Colorado Front Range* (Boulder: Colorado Associated University Press, 1974); *Robert Adams: To Make It Home: Photographs of the American West* (New York: Aperture Foundation, 1989); Anne Tucker, *Crimes and Splendors: The Desert Cantos of Richard Misrach* (Boston: Bulfinch Press in association with the Houston Museum of Fine Arts, 1996); and Mark Klett et al., *Second View: The Rephotographic Survey Project* (Albuquerque: University of New Mexico Press, 1984).

ROBERT ADAMS
From Flagstaff Mountain Above Boulder, 1985
Gelatin silver plate photograph, 5 x 5
Denver Art Museum, The Daniel Wolf Landscape Photography Collection
© Robert Adams, courtesy Fraenkel Gallery, San Francisco

matter that includes urbanism, consumer culture, and the enormous impact of immigration on current western life, it will remain a fundamentally backward-looking sort of art with a limited ability to address issues of current social interest, and it will reinforce popular ideas about the West as a place shaped by frontier culture. Likewise, as long as it depends upon a particular aesthetic style—that "straight photographic approach" Ansel Adams once hailed as quintessentially American—it will have a problematic relationship to a contemporary art market that values stylistic experimentation and flexibility.

As we try to consider a more expansive future for western art, however, we might imagine that photography's close relationship to popular culture and the vagaries of the marketplace make it the medium best poised to refashion the genre. Photography's sensitivity to popular taste makes it a nimble and adaptable sort of medium. As the lessons of the so-called "new" western history seep into popular culture and into the classroom, more Americans have begun to embrace the West as a region shaped not just by topography and a particular historical moment of pioneer settlement but by the ongoing interactions of a diverse group of peoples—with one another and with the physical environment. Who better than photographers to respond quickly to this shifting understanding of the region? In the mid-nineteenth century, painters helped define the acceptable style and content of early western photographs. But now, taking their cues from a different set of tastemakers and an ever-expanding sense of western culture, photographers seem particularly well-equipped to reposition the boundaries of western art and show how an old genre can find new vitality by exploring the complicated, vibrant West of the twenty-first century.

RICHARD MISRACH
Downed Safety Cone,
Bonneville Salt Flats, 1992
Color coupler print chromogenic
process, 41 x 51
Denver Art Museum, Funds from 1998
Alliance for Contemporary Art Auction

NORTH AMERICAN INDIANS.

Chasing the Phantom

Cultural Memory in the Image of the West

Few people even know the true definition of the term "West"; and where is its location?

—phantomlike it flies before us as we travel. — GEORGE CATLIN

There are "lieux de mémoire," sites of memory, because there are no longer "milieux de mémoire,"

real environments of memory. — PIERRE NORA[1]

Angela Miller

1. George Catlin, *Letters and Notes on the Manners, Customs, and Conditions of the North American Indians* (New York: Wiley and Putnam, 1841); and Pierre Nora, "Between Memory and History: 'Les Lieux de Mémoire,'" *Representations* 26 (Spring 1989): 7.

2. See Raymond Williams, *The Country and the City* (New York: Oxford University Press, 1973).

3. See Pierre Nora, "Between Memory and History"; also Richard Terdiman, *Present Past: Modernity and the Memory Crisis* (Ithaca: New York: Cornell University Press, 1993), for another but related reading of the memory problem and modern culture.

4. Jacques Ozouf and Mona Ozouf, "*Le Tour de la France par Deux Enfants:* The Little Red Book of the Republic," in *Realms of Memory: The Construction of the French Past*, vol. 2, *Traditions*, ed. Pierre Nora (New York: Columbia University Press, 1997), 148.

GEORGE CATLIN

North American Indians, no date

Lithograph, 22.125 x 15.75

Denver Art Museum, General acquisition fund

Modern cultures, defined by historical rupture and discontinuity, have places of eternal return toward which collective memories gravitate; places that symbolize a fullness of experience lacking amid the complexities of history itself. These *lieux de mémoires* give an identity and a name to the historical nostalgia that has accompanied modernization. For voyagers and immigrants to the United States, for Americans trapped in cities, for those who have been shaped by the nation's myths of heroic difference, the "Old West" is one such uniquely compelling place of memory.

For the English upper classes from the 1600s on, the focus of nostalgia was the rural countryside, a place that inspired visions of organic social connections, folk traditions, and seamless harmony with nature.[2] The French have multiple sites of memory; indeed the very concept of memory as constituting psychological integration, refuge, and reverie was invented by the French.[3] Pierre Nora, who coined the term *lieux de mémoire* ("sites of memory"), has noted that they are a distinctly modern phenomenon. Sites of memory take shape with the onset of historical self-consciousness—an awareness, that is, that one stands in a new relationship with the past, no longer continuous with it. Ways of life, embodied in buildings or villages or the historic landscape, become history when they are no longer a living presence in the culture. Places become sites of memory when they retrospectively acquire a deep emotional charge of something lost and retrievable only through ritual, representation, and symbolic investment. The invention of rites, rituals, performances, institutions, and myths that revivify these cultural sites of memory—giving them "the tremor and succulence of life"—occurred in both Europe and America in the 1800s, a time of dramatic rupture from a past of much longer duration.[4]

The reasons for this rupture are many and vary from culture to culture: in the United States, they include the transition from a predominantly rural and agrarian culture to an urban culture; from localized "island" communities to national networks of transportation, marketing and distribution; from domestic and small-scale production to centralized industries. The United States, it could be argued, is a nation itself created in the modern era, and therefore one that did not experience the sense of displacement

from a much older history—grounded in premodern ways and associations—that Europe did. Yet the corrosive flux of modernization, which brought about movement of people and transformation of places, turned generations of Americans to images of a more stable past. Nostalgia has accordingly been a defining feature of mass-manufactured images in film, popular illustration, tourism, and historic preservation. The origins of the United States coincided with a quickening industrial and social modernization in Europe; over the next century and a half, this proud new democratic nation would generate numerous "invented traditions."[5] Rodeos, which first appeared in the waning years of the cowboy era, helped keep alive the memory of that earlier time; spinning wheels, Thanksgiving, and endless centennials and bicentennials celebrated foundings and origins. The historical eras recollected by these traditions were relatively recent and of short duration in the grand scheme of things, but the accelerating pace of historical change made them seem like distant memories.

For eastern Americans in the late nineteenth century, the Old West was known not through direct experience, recollected and recorded by those who had been there, but through representations, reenactments, and performances. The Old West was not a place or a time in history, but a cultural invention that answered a post–Civil War longing for the certainties of heroic action and the permanence of sublime nature.[6] Its content shifted over time. Is there a stable point of origin *in history* from which to trace the myriad representations and imaginings of this mythic place?

Already by the mid-nineteenth century, the artist George Catlin intuitively grasped that the "West" was less a geographical locale linked to a particular moment in history than a place of memory, formed of a cultural longing as old, perhaps, as Europe's first encounter with the New World. This elusive West was a centuries-old aggregate of historical experience bonded inextricably with imagination and memory. It resembled our memories of loved ones, composed of faded photographs that slowly replace the mental recollection of experience itself—a memory of a memory.

The West that Catlin encountered along the upper Missouri River in the 1830s might seem a good candidate for the Old West. His often rough and unfinished portraits of the cultures of the northern Plains, done with a sense of urgency but attentive to the niceties of ceremonial regalia, body paint, and physiognomy, seem to address us from the other side of some historical watershed of authenticity. They appear to "document" rather than project, offering invaluable evidence of a seemingly innocent first encounter. Catlin—like many later artists of the Old West—took endless pains to emphasize the truth and authenticity of his images.[7] This is equally true of the extraordinary works of Karl Bodmer, which appear today as miracles of precise observation coupled with extraordinary artistry, a rare amalgam in the history of art.

Yet Catlin's mission to the West was motivated by a sense of historical belatedness; he was haunted by the knowledge that his encounter with this wondrous new land and people was already determined by the fatalities of history. The innocence of total possibility did not exist for him, because Catlin's experiences with the people of the upper Missouri were shaped by a historical script he carried with him from his first sighting of Indians walking solemnly through the streets of Philadelphia: the conviction, shared with most Americans of his generation, that the aboriginal cultures of the New World were unequipped by nature to withstand the pressures of development and destined to extinction. This script—"witnesses to a vanishing America"—gave birth to the very concept of the Indian Gallery, born of the early-nineteenth-century impulse to document cultures whose future was perceived as precarious.[8] Catlin's self-glorifying mission of cultural salvage repressed the recognition that his presence itself transformed the nature of what he observed. His sense of belatedness came from his knowledge that what he "experienced" at the boundary line between cultures was *already* the product of a historical dynamic set into motion decades before he arrived by a longer history of exchange with the fur-trading companies of Great Britain. Unable to stand outside of this history, Catlin nonetheless trafficked in the fiction of an inviolable moment of pristine perception.[9]

5. See Eric Hobsbawm and Terence Ranger, eds., *The Invention of Tradition* (New York: Cambridge University Press, 1983).

6. See Alex Nemerov's "Doing the 'Old America': The Image of the American West, 1880–1920," in *The West as America: Reinterpreting Images of the Frontier, 1820–1920,* ed. William H. Truettner (Washington, DC: Smithsonian Institution Press, 1991), 285–343; G. Edward White, *The Eastern Establishment and the Western Experience: The West of Frederic Remington, Theodore Roosevelt, and Owen Wister* (Austin: University of Texas Press, 1989); and Alex Nemerov, *Frederic Remington and the American Civil War: A Ghost Story* (Stockbridge, MA: Norman Rockwell Museum, 2006).

7. On Catlin's obsession with establishing his authenticity, see Brian Dippie, *Catlin and His Contemporaries: The Politics of Patronage* (Lincoln: University of Nebraska Press, 1990).

8. See Lee Clark Mitchell, *Witnesses to a Vanishing America: The Nineteenth-Century Response* (Princeton, NJ: Princeton University Press, 1981).

9. Catlin's presence in the upper Missouri River area was part of a broader transformation of the region that brought epidemics of smallpox, alcoholism, and intensifying conflict among Plains tribal people. See Kathryn S. Hight, "'Doomed to Perish': Catlin's Depictions of the Mandan," in "Depictions of the Dispossessed," special issue, *Art Journal* (Summer 1990), 119–24.

KARL BODMER

Dakota Woman and Assiniboin Girl,
ca. 1809-1893

Lithograph, 19.5 x 14.5

Denver Art Museum, Bequest of

Charles J. Norton

DACOTA INDIANERIN UND ASSINIBOIN MÄDCHEN. INDIENNE DACOTA ET JEUNE FILLE ASSINIBOINE
DAKOTA WOMAN AND ASSINIBOIN GIRL.

10. The literature on first-encounter images is voluminous. See for instance Hugh Honour, *The New Golden Land: European Images of America from the Discoveries to the Present Time* (New York: Pantheon Books, 1975); and Rachel Doggett, ed., *New World of Wonders: European Images of the Americas, 1492–1700* (Seattle: University of Washington Press, 1992).

11. See Kenneth John Myers, "On the Cultural Construction of Landscape Experience: Contact to 1830," in *American Iconology: New Approaches to Nineteenth-Century Art and Literature,* ed. David Miller (New Haven, CT: Yale University Press, 1993), 62–64.

Such trafficking in nostalgia was a recurrent feature of Europe's conquest and colonization of the New World, a form of "soft" primitivism that found in the colonized cultures an innocence and virtue lacking among more "civilized" societies. Catlin's dignified plainsmen were descendants of a long line of noble savages traceable to the Renaissance, when European intellectuals first responded to the wonders of the New World.[10] These earliest representations were themselves framed by the already known. As one pursues the history of first-encounter images, one finds oneself impelled by a phantom resembling Catlin's own "West of the imagination." Understanding of the new is often framed in terms of resemblance to the known. And herein lies the key to the endless regress of representation: something new, which is the substance of exploration and first encounter, enters cultural knowledge and discourse frequently through its linkage to something already known—that is, through resemblance.[11] Columbus's first encounter with the New World, for instance, convinced him that he had found Eden, initiating a centuries-long fascination with what Europeans perceived as a space of spiritual and social redemption on the far side of the Atlantic. Europe's encounter with the Western hemisphere was tempered by a sense of the already known, a kind of *epistemological* belatedness. For many in this first century of exploration of the Americas, the New World did not seem so new.

If we often know new realities through resemblance, this resemblance may be to previous literary and artistic representations. European representations of New World cultures draw upon earlier images of barbaric nomads on the periphery of the civilized world, traceable to Greco-Roman antiquity. The metopes of the Parthenon depict the battle between the Lapiths and the half-man, half-beast Centaurs; thus at the cultural and political height of the Greek city-state of Athens, the basic terms of the savage and the civilized were already set. And while the values associated with savage and civilized would change over time, their fundamental opposition persisted through the late nineteenth century.

Yet we still can—and should—distinguish between the historical West Catlin represented—the West of the frontier—and the mythic West that drove him onward in search of new, more innocent encounters. The historical frontier of Catlin's era was an unstable and fragile meeting point between cultures, a zone of intercultural encounter

12. Joy S. Kasson, *Buffalo Bill's Wild West: Celebrity, Memory, and Popular History* (New York: Hill and Wang, 2000), 72–74.

13. Frederick Jackson Turner, "The Significance of the Frontier in American History," in *Rereading Frederick Jackson Turner: The Significance of the Frontier in American History and Other Essays*, ed. John Mack Faragher (New York: H. Holt, 1994), 31–60.

CHARLES M. RUSSELL
The Bronc Twister, ca. 1929-1934
Bronze, 17.25 x 14.235 x 11.75
Denver Art Museum, Gift of Sharon Magness

GEORGE CATLIN
Wi-Jun-Jon, The Pigeon's Egg Head, Going to Washington, Returning to his Home, no date; Lithograph, 22.125 x 15.75
Denver Art Museum, Gift of George Shriever

FACING PAGE, TOP:
CHARLES M. RUSSELL
That Night in Blackfoot Was a Terror, 1910
Watercolor on paper, 16 x 13
Denver Art Museum, In memory of Dr. John Cunningham, a gift of His Granddaughter

FACING PAGE, BOTTOM:
HARRY JACKSON
Two Champs, 1978
Bronze, 54.5 x 38 x 21.5
Denver Art Museum, ©2006 Harry Jackson Trust. All rights reserved.

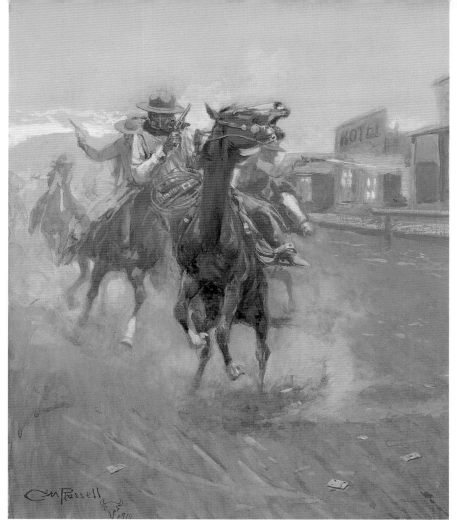

where the inevitable process of degeneration began; the zone where Plains Indians struggled with alcohol, disease, and the dangerous blandishments of civilization in what Catlin and his contemporaries were convinced was a downward spiral toward cultural extinction. The mythic West he wistfully invoked was something else, appealing precisely because it *was* pristine, beyond time, and beyond both progress and declension.

Which of these two versions of the West—the historical West or the mythic West—is the Old West that served as a site of memory for Americans in the late 1800s? Both held a place of honor as a locus of cultural meaning and symbolic attachment. If one is the West in time and history, the other is the West in space. The first is born of the headlong rush of modernizing forces, of progressively unfolding stages of social evolution mythologized by countless bombastic pronouncements. This West reaches from Bishop Berkeley's vision of westward-marching empire of 1752 to Frederick Jackson Turner's frontier thesis of 1893 and beyond. It is defined by temporality; its very identity is that it is transitory, fleeting, a quaint stop—though much regretted once it is passed by—on the highway to cultural ascendancy. This West was rooted once again in nostalgia for the places and experiences and characters lost in the establishment of a progressive "West as America." This was a West of invented traditions, myths, and representations; the labor of artists, writers, filmmakers, and composers. It is the West of Buffalo Bill, whose Wild West in 1886 featured "The Drama of Civilization" in five acts, beginning with "The Forest Primeval" and proceeding through "The Prairie," "The Cattle Ranch," "The Mining Camp," and concluding with "The Last Charge of Custer."[12] In his famous 1893 essay "The Significance of the Frontier in American History," Turner declared that the frontier era was officially over. In describing the frontier, he recapitulated the same unfolding sequence of stages on the path to colonization of the West. His "frontier thesis," as it came to be known—for decades the very foundation block of western history—codified ideas with very deep roots in national culture and popular visions of the West, ideas that had as much to do with myth and memory as they did with western history.[13]

The formative period of the historical, frontier version of the Old West as a site of memory occurred in the decades after the Civil War. But it continued unabated well into the twentieth century and remains a mainstay of the market in western art today. Charles Marion Russell's *That Night in Blackfoot Was a Terror* vividly realizes a Wild West of shootouts and vigilante justice known first through the dime novels that began circulating in the 1880s. Harry Jackson's *Two Champs* is a humorous restaging of the bronco busters and wild-eyed

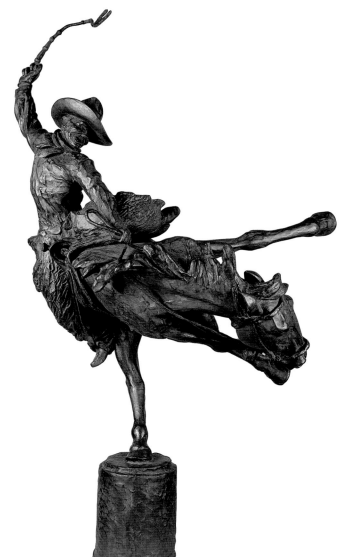

LYELL CARR
Remington's New Rochelle, New York studio, 1900
Oil on canvas, 27 x 40
Courtesy of the Frederic Remington Art Museum, Ogdensburg, New York

cowboys of Remington, Russell (*The Bronco Twister*), and Alexander Phimister Proctor (*Buckaroo*). This West was a picturesque and immensely compelling fantasy world that appealed to those living more contracted urban lives and nursing a diminished sense of manhood.

The other West that is a contender as a site of memory took shape in space rather than in time. Its appeal was Edenic—a prelapsarian garden, exempt from history and thus in some sense the inversion of the temporally driven "West as America." When Albert Bierstadt painted his paradisiacal views of Yosemite, he was already outside the gates, looking in upon a scene he witnessed, first and foremost, as representation. Filtered by centuries of imagining and by layers of myth and cultural memory, Bierstadt's Yosemite was as much remembered as seen firsthand. Late-nineteenth-century paintings and photographs of Yosemite derived as much from earlier conventions of the pastoral and from earlier landscape compositions as from the actual experience of the site itself. Yosemite resonated with familiar and very longstanding cultural tropes. One effusive reviewer wrote in 1865 that "it looks as if it was painted in an Eldorado, in a distant land of gold; heard of in song and story; dreamed of, but never seen. Yet it is real."[14] Bierstadt's images of Yosemite—a beautiful garden surrounded by towering stone walls—spoke to a broader communal fantasy of a place sealed off, fortresslike, from history itself, impossibly pristine and unassailable.[15] Through his canvases, the myth of the West as new golden land came vividly, resplendently alive before the eyes of his audience. Gazing at Bierstadt's paintings of Yosemite, viewers must have had a "shock of recognition," as if discovering something already known in memory yet miraculously heightened—images of earlier Edens and mythic gardens—a Hesperides of the imagination. The almost celestial refulgence that floods the valley recalls Old and New Testament iconography of light linked to moments of epiphany—part of an artistic tradition Bierstadt knew well and also an inheritance from the Bible and classical antiquity. The smooth buttery finish of his works suggests the surfaces not of nature but of art, of Old Masters such as Claude Lorrain and his inheritor, the English landscape artist J. M. W. Turner. Bierstadt acknowledged his position within a tradition of landscape art going back to the 1600s, a fitting tribute to America's new standing as a nation among nations, with an artistic culture worthy of its hard-won maturity after a war that cost over 600,000 lives.

14. Quoted in Nancy Anderson, *Albert Bierstadt: Art and Enterprise* (New York: Hudson Hills Press, in association with the Brooklyn Museum, 1990), 201.

15. See James Gorman, "Yosemite and the Invention of Wilderness," *New York Times*, September 2, 2003, sec. D.

FACING PAGE, TOP:
ALBERT BIERSTADT
Looking Down Yosemite Valley, California, 1865
Oil on Canvas, 64.5 x 94.5
Birmingham Museum of Art, Alabama; Gift of the Birmingham Public Library

FACING PAGE, BOTTOM:
ALEXANDER PHIMISTER PROCTOR
Buckaroo, 1915
Bronze, 27 x 20 x 8
Denver Art Museum, Funds from William Sr. and Dorothy Harmsen Collection by exchange

【 73 】

E. IRVING COUSE
Crouching Indian by a Fire, ca. 1910
Oil on canvas, 11.375 x 15.375
Denver Art Museum, Collectors' Choice
Benefit Fund, 1986

At the same time, Bierstadt's paintings of Yosemite, sparked into life by their hyperrealism, aspire to transparency: their breathtaking effects, their panoramic size, and their meticulous detail all contribute to a "reality effect" in which the artist suppresses signs of their status as representation in an effort to touch into life the golden West of myth and memory. As Alex Nemerov has argued, such reality effects defined the late-nineteenth-century art of the Old West, most conspicuously in the art of Remington and Russell.[16] Many in Bierstadt's audience were taken in by the hyperrealism of his style. What is more, in a pictorial version of an alibi, the truth of Bierstadt's image was confirmed by the independent testimony of such photographers as Carleton Watkins (see Sandweiss, this volume), whose photographs of Yosemite were understood as objective and indisputable. Bierstadt endowed his version of the West with the power of the real.

Another version of the West as a space beyond history shaped itself around what many thought of as the unchanging world of the Indian. Works by artists mostly trained in Paris convey a posed and shrouded quality, as if they are reconstructions of memories long cherished but existing at several removes from life and history. Such recreations of a remembered and imagined West characterize the early-twentieth-century work of Taos and Santa Fe artists such as Oscar E. Berninghaus and the Paris-trained lyricist E. Irving Couse. If these artists denied the impact of a sometimes ruthless colonizing process on Indian cultures, other artists in these years transformed the plight of Plains cultures at the end of the nineteenth century into elegiac images of cultural loss and displacement. Henry Farny is best known for melancholy scenes of native people wandering at the edges of a changing world. Trudging through wintry landscapes or contemplating signs of progress, they seem driven onward by the demons of development. It was, oddly, their strange anachronism—their evocation of wistful regret for older premodern ways—that appealed to the audiences of the 1890s and early 1900s.[17]

16. Nemerov, "Doing the 'Old America,'" 290. Nemerov and the present essay borrow this concept from Roland Barthes's classic essay "L'Effet du Réel."

17. On Farny, see Julie Schimmel, "Inventing the Indian," in Truettner, *West as America,* 171–73.

Charles Russell, by contrast, skillfully conjured a West when Plains Indian cultures were at their height, but he does so, once again, through the mediation of earlier artists. Russell's *Buffalo Hunt*, for instance, draws on a decades-long tradition going back to Charles Wimar and forward to Bierstadt and the English artist James Walker. Bierstadt's *Last of the Buffalo* reprises the theme of the buffalo hunt at the century's end in a painting that was also a swan song to his own career as an artist whose fame and fortune were grounded on western subjects. *Last of the Buffalo,* painted in 1888, acknowledges through its very theatricality the displacement of lived memories by spectacle.

HENRY FARNY
Laramie Creek, 1907
Gouache on board, 11.25 x 17.5
Denver Art Museum, Gift of
Katharine T. Benedict

ALBERT BIERSTADT
Last of the Buffalo, ca. 1888
Oil on canvas, 60.25 x 96.5
Buffalo Bill Historical Center, Cody,
Wyoming; Gertrude Vanderbilt
Whitney Trust Fund Purchase; 2.60

As the powerful new medium of film entered the cultural landscape, the conversation among the mythmakers of the Old West was vastly enriched. The early film western looked back to the dime novels and Wild West shows of the late 1800s. Charles Russell, and slightly later Norman Rockwell (*The Stagecoach*, page 20 and cover), imagined the frontier through the lens of the film western, as Alex Nemerov has argued, and in turn film directors like John Ford drew on the work of Frederic Remington to endow their images with the uncanny cultural resonance of the long-familiar. Through such conversations between representational forms and cultural mythmakers, the Old West of cultural invention assumed the status of the real.[18]

The late nineteenth century saw a distinctive new development that differed in a fundamental respect from earlier ways of imagining the Old West as a site of memory. In a handful of trompe l'oeil "trophy" paintings done in the final two decades of the century, the West is represented not as historical memory—that is, as a place of flesh-and-blood encounters—nor as a timeless Arcadia where the motions of history were eternally suspended but as an imaginary place existing *only* through representations, trophies, and icons.[19] Astley M. Cooper's *Relics of the Past* is a tribute to Buffalo Bill's Wild West, and the painting was actually owned by Buffalo Bill.[20] *Relics of the Past* sets the viewer at eye level with the creature who more than any other symbolized for nineteenth-century Americans the feral power, inexhaustibility, and sublime nature of the West of myth and memory. The buffalo head is framed against a studded blue leather background, its power contained and transformed into a trophy of defeat. The theme of defeat echoes as well in the worn and frayed photographs of native warriors, conquered first by the U.S. Army and then by the camera: Sitting Bull and Red Cloud are pinned to the rust-red wall like specimens in a scientific display, with tacks that cast their own shadows. Like the buffalo head, they have become trophies of America's war of conquest in the West. Appearing alongside them are photographs of James Butler ("Wild Bill") Hickok, Frank Gruard, and D. F. Barry GALL Bismarck Dak—performers in the Wild West. At the top of the image is a photograph of Buffalo Bill Cody, symbolically placed at the center point of the buffalo head, as well as at the juncture of a tomahawk and a native pipe, two crossed emblems of the older history of Plains warfare and intercultural conflict. Horseshoe-shaped marks on the metal head of the tomahawk "count coup" on the enemy, recalling the hand-to-hand combat of earlier Plains warfare before the introduction of firearms. To the left, hanging from another nail, is a war club whose head is formed of the jaw of an animal.

The photograph of Cody is one of many ironic moments in Cooper's painting. Considerably diminished in size in relation to the still-majestic buffalo head with its glossy horns and flared nostrils, the photograph still asserts power and authority by its position at the top of the painting—a sardonic comment on the growing power of the image over the lived three-dimensional reality.

The entire ensemble of objects shown in *Relics of the Past* not only suggests the kind of arrangement found in the studios, saloons, and smoking rooms of prosperous eastern businessmen but also recalls a dynastic coat of arms with its bilateral symmetry and heraldry. As with European family coats of arms, this one is based on much older heroic feats of valor, now recalled as episodes in the dynastic history of the United States in its triumphal passage westward.

Why then Buffalo Bill—a showman rather than a real actor in the conquest of the West? His presence transforms the significance of the other photographs: the Plains warriors are there not as representatives of noble defeat but as "show Indians," members of the traveling Wild West produced by Buffalo Bill himself. First presented to the public in 1883, his Wild West became an international phenomenon and was the only version of the Old West known to many Americans and their European contemporaries. Plains warriors such as Sitting Bull reenacted onstage their exploits in the Indian wars of the 1870s and 1880s, achieving a second celebrity not as historical figures but as stage actors.[21]

18. See Alex Nemerov, "Projecting the Future: Film and Race in the Art of Charles Russell," *American Art* (Winter 1994): 70–89.

19. See for instance Alexander Pope's painting, *Weapons of War* (1900), in the Buffalo Bill Historical Center, Cody, Wyoming.

20. Thanks to Christine Brindza, Curatorial Assistant at the Whitney Gallery of Western Art, Buffalo Bill Historical Center, for information on the painting.

21. On the "Wild West" of Buffalo Bill, see Kasson, *Buffalo Bill's Wild West*; Sam Maddra, *Hostiles?: The Lakota Ghost Dance and Buffalo Bill's Wild West* (Norman: University of Oklahoma Press, 2006); and Bobby Bridger, *Buffalo Bill and Sitting Bull: Inventing the Wild West* (Austin: University of Texas Press, 2002).

Painted the same year as the massacre of some three hundred men, women, and children at Wounded Knee, North Dakota, *Relics of the Past* at first glance seems a reliquary to a place and a time gone forever, to be retrieved only in memory. It commemorates the conclusion of the centuries-long conquest of the West that began with the first landfall of Columbus. This conquest is signaled not only by the transformation of weapons of war into heraldry but also by the transformation of historical experience into spectacle and historical figures into stage actors. Further mediating our access to the historical West is the presence of photography, or, more precisely, painted images of photographs—history, in short, at three removes: a painting of a photograph of a warrior famous for playing himself in Buffalo Bill's Wild West.

In this dense web of representation, where is the "real" West? The authentic West, which Buffalo Bill himself trumpeted to his audiences? What separated Cooper's from Bierstadt's West was not merely its acute awareness of historical belatedness—its knowledge, that is, that the fullness of the Old West as experience is irretrievable—but also that the Old West itself may have only *ever* existed as representation.

Perhaps, though, that is putting a postmodern spin on the painting, if by postmodern we mean that it knowingly engages western sites of memory *as memory* rather than as history. The issue turns on how much power of historical self-reflection we attribute to Cooper. Cooper's painting seems to resolve these western sites of memory not into some prior authoritative experience to which they dedicate their power as images, but into other

E. IRVING COUSE

War Dance at Glorietta, 1903

Oil on canvas, 35 x 46

Denver Art Museum, William Sr. and

Dorothy Harmsen Collection

images. The photographs of Sitting Bull and others may commemorate their careers as great warriors or they may allude to their celebrity as performers in Buffalo Bill's Wild West. Since it is the latter who presides over the collection of western artifacts, the entire painting teeters on the edge of postmodern irony, as spectacle replaces historical experience and the celebrity of the "show" Indians replaces their standing as historical actors.

Cooper's *Relics of the Past* commemorates the transformation of historical memory (rooted in real environments) into isolated remnants of the past, taken out of context. It is a tribute to lost illusions: the West imagined as the arena of a mythic American manhood as powerful as western nature itself. *Relics of the Past* reflects on the cultural will to resurrect that which is gone, but also the impossibility of doing so.[22]

At their most compelling, western sites of memory reawaken—if only in imagination—that transitory moment so longingly invoked by F. Scott Fitzgerald at the end of his 1925 novel *The Great Gatsby*. For that transitory moment when sailors from the Old World encountered the New World for the first time, "man must have held his breath in the presence of this continent, compelled into an aesthetic contemplation he neither understood nor desired, face to face for the last time in history with something commensurate to his capacity for wonder." For the last time in history. Everything since that mythic moment has been an eternal return, a longing to recapture something we know only in words and images, a place where imagination and history are, for once, in perfect harmony.

22. Although there is, as Martha Sandweiss has pointed out, an additional irony in the fact that Buffalo Bill's "Wild West" gave nurture and sustenance both to embattled buffalo—their herds decimated by these years—as well as to Plains Indians, who used the proceeds from the show to benefit their people. Buffalo Bill, in a *New York Sun* interview in the 1880s, expressed concern for the depletion of the great herds of the West, situating him among the early proponents of Plains conservation. Thanks to Paul Fees, formerly Senior Curator at the Buffalo Bill Historical Center (phone conversation).

A. D. M. COOPER
Relics of the Past, ca. 1890
Oil on canvas, 40 x 36
Buffalo Bill Historical Center, Cody, Wyoming; Bequest in Memory of the Houx and Newell Families; 4.64

Adams, Ansel. *Pageant of Photography.* San Francisco: Crocker-Union, 1940.

Adams, Robert. *New Topographics: Photographs of a Man-Altered Landscape.* Rochester, NY: George Eastman House, 1975.

_____. *The New West: Landscapes Along the Colorado Front Range.* Boulder: Colorado Associated University Press, 1974.

_____. *Robert Adams: To Make It Home: Photographs of the American West.* New York: Aperture Foundation, 1989.

Anderson, Nancy K. *Albert Bierstadt: Art and Enterprise.* New York: Hudson Hills Press, in association with the Brooklyn Museum, 1990.

_____. "'Curious Historical Artistic Data': Art History and Western American Art." In *Discovered Lands, Invented Pasts: Transforming Visions of the American West,* by Jules David Prown et al., 1–35. New Haven, CT: Yale University Press for Yale University Art Gallery, 1992.

_____. *Frederic Remington: The Color of Night.* Washington, DC: National Gallery of Art, 2003.

Avedon, Richard. *In the American West.* New York: Harry N. Abrams, Inc., 1985.

Bockrath, Mark F. "'Frank Imagination, within a Beautiful Form': The Painting Methods of Maxfield Parrish." In *Maxfield Parrish, 1870–1966,* by Sylvia Yount, 122–51. New York: Harry N. Abrams, Inc., in association with the Pennsylvania Academy of Fine Arts, Philadelphia, 1999.

Bold, Christine. "*Malaeska*'s Revenge: The Dime Novel Tradition in Popular Fiction." In *Wanted Dead or Alive: The American West in Popular Culture,* edited by Richard Aguila, 21–42. Urbana, IL: University of Illinois Press, 1996.

Boorstin, Daniel. *The Americans: The National Experience.* New York: Random House, 1965.

Bossen, Howard. "A Tall Tale Retold: The Influence of the Photographs of William Henry Jackson on the Passage of the Yellowstone Park Act of 1872." *Studies in Visual Communications* 8, no. 1 (Winter 1982): 98–109.

Bridger, Bobby. *Buffalo Bill and Sitting Bull: Inventing the Wild West.* Austin: University of Texas Press, 2002.

California Academy of Sciences. *Maynard Dixon, Images of the Native American.* San Francisco: California Academy of Sciences, 1981.

Catlin, George. *Letters and Notes on the Manners, Customs, and Conditions of the North American Indians.* New York: Wiley and Putnam, 1841.

Cawelti, John G. *The Six-Gun Mystique Sequel.* Bowling Green, OH: Bowling Green State University Popular Press, 1999.

Corn, Wanda. "Coming of Age: Historical Scholarship in American Art." *Art Bulletin* 70 (June 1988): 188–207.

Current, Karen. *Photography and the Old West.* New York: H. N. Abrams, 1978.

Deloria, Philip J. *Indians in Unexpected Places.* Lawrence: University Press of Kansas, 2004.

Denenberg, Thomas Andrew. "American Art at Reynolda House." *American Art Review* 17 (June 2005): 88–95.

Detroit Institute of Arts and the National Gallery of Art. *American Paintings from the Manoogian Collection.* Washington, DC: National Gallery of Art, 1989.

Dippie, Brian W. "Afterword: Remington Schuyler and the American Illustrative Tradition." In *Remington Schuyler's West: Artistic Visions of Cowboys and Indians,* compiled by Henry W. Hamilton and Jean Tyree Hamilton, 87–109. Pierre: South Dakota State Historical Society Press, 2004.

_____. *Catlin and His Contemporaries: The Politics of Patronage.* Lincoln: University of Nebraska Press, 1990.

_____. "'Chop! Chop!': Progress in the Presentation of Western Visual History." *The Historian* 66 (Fall 2004): 491–500.

_____. "Drawn to the West." *Western Historical Quarterly* 35 (Spring 2004): 5–26.

_____. *The Frederic Remington Art Museum Collection.* New York: Frederic Remington Art Museum in association with Harry N. Abrams, 2001.

_____. *Looking at Russell.* Fort Worth, TX: Amon Carter Museum, 1987.

_____. "Of Documents and Myths: Richard Kern and Western Art." *New Mexico Historical Review* 61 (April 1986): 147–58.

_____. "The State of Russell Scholarship." In *Charles M. Russell, Legacy: Printed and Published Works of Montana's Cowboy Artist,* edited by Larry Len Peterson, x–xi. Helena, MT: Twodot Books, 1999.

_____. "The Visual West." In *The Oxford History of the American West,* edited by Clyde A. Milner II, Carol A. O'Connor, and Martha A. Sandweiss, 675–705. New York: Oxford University Press, 1994.

_____. "Western Art Don't Get No Respect: A Fifty-Year Perspective." *Montana: The Magazine of Western History* 51 (Winter 2001): 68–71.

Doggett, Rachel, ed. *New World of Wonders: European Images of the Americas, 1492–1700.* Seattle: University of Washington Press, 1992.

Doss, Erika. "Hangin' Out at the Leanin' Tree: Mastery and Mythos in Western American Art, Old and New." *Journal of the West* 40, no. 4 (Fall 2001): 16–25.

Eldredge, Charles C., and Barbara B. Millhouse. *American Originals: Selections from Reynolda House, Museum of American Art.* New York: Abbeville Press, 1990.

Ewers, John C. *Artists of the Old West.* New York: Doubleday, 1965; reissued with additional chapters in 1973.

_____. "Fact and Fiction in the Documentary Art of the American West." In *The Frontier Re-examined,* edited by John Francis McDermott, 79–95. Urbana: University of Illinois Press, 1967.

Farr, William E. "Going to Buffalo: Indian Hunting Migrations across the Rocky Mountains." Pts. 1 and 2. *Montana: The Magazine of Western History* 53 (Winter 2003): 2–21; 54 (Spring 2004): 26–43.

Flexner, James Thomas. *That Wilder Image: The Painting of America's Native School from Thomas Cole to Winslow Homer.* Boston: Little, Brown, 1962.

Foxley, William C. *Frontier Spirit: Catalog of the Collection of the Museum of Western Art.* Denver: Museum of Western Art, 1983.

Goetzmann, William H., and William N. Goetzmann, *The West of the Imagination.* New York: W. W. Norton & Company, 1986.

Goodrich, Lloyd. *Art of the United States: 1670–1966.* New York: Whitney Museum of American Art, 1966.

Goodyear, Frank H. III. *Red Cloud: Photographs of a Lakota Chief.* Lincoln: University of Nebraska Press, 2003.

Haltman, Kenneth. *The Forgotten Expedition: Natural History, Documented and Imagined in the Art of Samuel Seymour and Titian Ramsey Peale, 1818–1823.* State College: Pennsylvania State University Press, forthcoming.

Hassrick, Peter H. "The Elements of Western Art." In *The American West: Out of Myth, Into Reality,* 15–56. Washington, DC: Trust for Museum Exhibitions, 2000.

_____. "Western Art Museums: A Question of Style or Content." *Montana: The Magazine of Western History* 42 (Summer 1992): 30–33.

_____. "William Ranney: A Painter's Requiem to the Mountain Man." *Montana: The Magazine of Western History* 56 (Summer 2006): 42–53.

Hennessey, Maureen Hart, and Anne Knutson, et al. *Norman Rockwell: Pictures for the American People.* Atlanta, GA: High Museum of Art, with the Norman Rockwell Museum, Stockbridge, MA, in association with Harry N. Abrams, New York, 1999.

Hight, Kathryn S. "'Doomed to Perish': Catlin's Depictions of the Mandan." In "Depictions of the Dispossessed," special issue, *Art Journal* (Summer 1990): 119–24.

Hills, Patricia. *The American Frontier: Images and Myths.* New York: Whitney Museum of American Art, 1973.

_____. *The Painters' America: Rural and Urban Life, 1810–1910.* New York: Whitney Museum of American Art, 1974.

Hobsbawm, Eric, and Terence Ranger, eds. *The Invention of Tradition.* New York: Cambridge University Press, 1983.

Honour, Hugh. *The New Golden Land: European Images of America from the Discoveries to the Present Time.* New York: Pantheon Books, 1975.

Howat, John K., and John Wilmerding. *19th–Century America: Paintings and Sculpture.* New York: Metropolitan Museum of Art, 1970.

Johns, Elizabeth. *American Genre Painting: The Politics of Everyday Life.* New Haven, CT: Yale University Press, 1991.

_____. "La Farge and Remington." *Art Journal* 47 (Fall 1988): 241–43.

Johnson, Ruth Carter. Foreword to *Charles M. Russell: Paintings, Drawings and Sculpture in the Amon G. Carter Collection—A Descriptive Catalogue,* by Frederic G. Renner. Austin: University of Texas Press, 1966.

_____. Preface to *Inaugural Exhibition: Selected Works / Frederic Remington and Charles Marion Russell.* Fort Worth, TX: Amon Carter Museum of Western Art, 1961.

_____. Foreword to *Frederic Remington: Paintings, Drawings, and Sculpture in the Amon Carter Museum and the Sid W. Richardson Foundation Collections,* by Peter H. Hassrick. New York: Harry N. Abrams, Inc., 1973.

Jones, Daryl. *The Dime Novel Western.* Bowling Green, OH: Popular Press, 1978.

Kasson, Joy S. *Buffalo Bill's Wild West: Celebrity, Memory, and Popular History.* New York: Hill and Wang, 2000.

Kinsey, Joni L. *Plain Pictures: Images of the American Prairie.* Washington, DC: Smithsonian Institution Press for the University of Iowa Museum of Art, 1996.

_____. *Thomas Moran's West: Chromolithography, High Art, and Popular Taste.* Lawrence, KS: University Press of Kansas, 2006.

_____. "Viewing the West: The Popular Culture of American Western Painting." In *Wanted Dead or Alive: The American West in Popular Culture*, edited by Richard Aguila, 243–68. Urbana, IL: University of Illinois Press, 1996.

Klett, Mark, Rick Dingus, Ellen Manchester, Gordon Burshaw, and Jo Ann Verburg. *Second View: The Rephotographic Survey Project.* Albuquerque: University of New Mexico Press, 1984.

Loy, R. Philip. *Westerns in a Changing America, 1955–2000.* Jefferson, NC: McFarland & Company, Inc., 2004.

Lusted, David. *The Western.* New York: Longman Publishing, 2003.

Maddra, Sam A. *Hostiles?: The Lakota Ghost Dance and Buffalo Bill's Wild West.* Norman: University of Oklahoma Press, 2006.

McCracken, Harold. *Portrait of the Old West.* New York: McGraw-Hill, 1952.

Merlock, Ray. Preface to *Hollywood's West: The American Frontier in Film, Television, and History*, edited by Peter C. Rollins and John E. O'Connor. Lexington: University Press of Kentucky, 2005.

Metropolitan Museum of Art. *American Paintings and Historical Prints from the Middendorf Collection.* New York: Metropolitan Museum of Art, 1967.

Mitchell, Lee Clark. *Witnesses to a Vanishing America: The Nineteenth-Century Response.* Princeton, NJ: Princeton University Press, 1981.

Moos, Dan. *Outside America: Race, Ethnicity, and the Role of the American West in National Belonging.* Hanover and Lebanon, NH: Dartmouth College Press and University Press of New England, 2005.

Moses, L. G. *Wild West Shows and the Images of American Indians, 1883–1933.* Albuquerque: University of New Mexico Press, 1996.

Museum of Fine Arts, Boston. *M. and M. Karolik Collection of American Paintings, 1815–1865.* Cambridge, MA: Harvard University Press, 1949.

Myers, Kenneth John. "On the Cultural Construction of Landscape Experience: Contact to 1830." In *American Iconology: New Approaches to Nineteenth-Century Art and Literature*, edited by David Miller, 62–64. New Haven, CT: Yale University Press, 1993.

National Gallery of Art. *An American Point of View: The Daniel J. Terra Collection.* Giverny, France: Musée d'Art Américain Giverny Publications, 2002.

Naef, Weston J. *Era of Exploration: The Rise of Landscape Photography in the American West, 1860–1885*, in collaboration with James N. Wood. Buffalo, NY: Albright-Knox Art Gallery in association with New York Graphic Society, 1975.

Neff, Emily. *Frederic Remington: The Hogg Brothers Collection of the Museum of Fine Arts, Houston.* Houston and Princeton, NJ: Museum of Fine Arts, Houston, and Princeton University Press, 2000.

Nemerov, Alex. *Frederic Remington and the American Civil War: A Ghost Story.* Stockbridge, MA: Norman Rockwell Museum, 2006.

_____. *Frederic Remington and Turn-of-the-Century America.* New Haven, CT: Yale University Press, 1995.

_____. "Projecting the Future: Film and Race in the Art of Charles Russell." *American Art* (Winter 1994): 70–89.

Nora, Pierre. "Between Memory and History: 'Les Lieux de Mémoire.'" *Representations* 26 (Spring 1989): 7–24.

Novak, Barbara. *American Painting of the Nineteenth Century: Realism, Idealism, and the American Experience.* New York: Praeger, 1969.

_____. *Nature and Culture: American Landscape and Painting, 1825–1875.* New York: Oxford University Press, 1980.

Prown, Jules David. "Mind in Matter: An Introduction to Material Culture Theory and Method." *Winterthur Portfolio* 17 (Spring 1982): 1–19.

Ratcliff, Carter. *Red Grooms.* New York: Abbeville Press, 1984.

Reddin, Paul. *Wild West Shows.* Urbana: University of Illinois Press, 1999.

Richardson, Edgar P. *American Art: An Exhibition from the Collection of Mr. and Mrs. John D. Rockefeller III: A Narrative and Critical Catalogue.* San Francisco: M. H. de Young Memorial Museum, 1976.

Roark, Carol E., Paula Ann Stewart, and Mary Kennedy McCabe. *Catalogue of the Amon Carter Museum Photography Collection* Fort Worth, TX: Amon Carter Museum, 1993.

Rockwell, Norman, as told to Thomas Rockwell. *Norman Rockwell: My Adventures as an Illustrator.* Indianapolis, IN: Curtis Publishing Company, 1979.

Rossi, Paul, and David Hunt. *The Art of the Old West, from the Collection of the Gilcrease Institute.* New York: Alfred A. Knopf, 1971.

Rushing, W. Jackson. "Authenticity and Subjectivity in Post-War Painting: Concerning Herrera, Scholder, and Cannon." In *Shared Visions: Native American Painters and Sculptors in the Twentieth Century*, edited by Margaret Archuleta and Rennard Strickland, 12–21. Phoenix: The Heard Museum, 1991.

Rydell, Robert W., and Rob Kroes. *Buffalo Bill in Bologna: The Americanization of the World, 1869–1922.* Chicago: University of Chicago Press, 2005.

Sandweiss, Martha A. *Print the Legend: Photography and the American West.* New Haven, CT: Yale University Press, 2002.

Saunders, Richard H. *Collecting the West: The C. R. Smith Collection of Western American Art.* Austin: University of Texas Press, 1988.

Savage, William W. Jr. *Commies, Cowboys, and Jungle Queens: Comic Books and America, 1945–1954.* Hanover, NH: Wesleyan University Press and University Press of New England, 1998.

Schroeder, Charles P. Foreword to *A Western Legacy: The National Cowboy & Western Heritage Museum.* Norman: University of Oklahoma Press, 2005.

Scholder, Fritz. *Indian Kitsch: The Use and Misuse of Indian Images.* Flagstaff, AZ: Northland Press, 1979.

Shapiro, Michael Edward, and Peter H. Hassrick. *Frederic Remington: The Masterworks.* New York: Abrams, 1988.

Smith, C. R. Introduction to *Inaugural Exhibition: Selected Works / Frederic Remington and Charles Marion Russell.* Fort Worth, TX: Amon Carter Museum of Western Art, 1961.

Splete, Allen P., and Marilyn D. Splete, eds. *Frederic Remington—Selected Letters.* New York: Abbeville Press, 1988.

Stebbins, Theodore E. Jr., Carol Troyen, and Trevor J. Fairbrother. *A New World: Masterpieces of American Painting, 1760–1910.* Boston: Museum of Fine Arts, 1983.

Stein, Roger B. "Packaging the Great Plains." *Great Plains Quarterly* 5 (Winter 1985): 5–23.

Streeby, Shelley. *American Sensations: Class, Empire, and the Production of Popular Culture.* Berkeley: University of California Press, 2002.

Strong, Lisa M. *Alfred Jacob Miller and the Art of the American West.* Fort Worth, TX: Amon Carter Museum, forthcoming.

Taft, Robert. *Artists and Illustrators of the Old West, 1850–1900.* New York: Scribner, 1953.

Terdiman, Richard. *Present Past: Modernity and the Memory Crisis.* New York: Cornell University Press, 1993.

Tomkins, Jane. *West of Everything: The Inner Life of Westerns.* New York: Oxford University Press, 1994.

Troccoli, Joan Carpenter. *Painters and the American West: The Anschutz Collection.* Denver and New Haven, CT: Denver Art Museum and Yale University Press, 2000.

Troyen, Carol. "The Incomparable Max: Maxim Karolik and the Taste for American Art." *American Art* 7 (Summer 1993): 64–87.

Truettner, William H., ed. *The West as America: Reinterpreting Images of the Frontier, 1820–1920.* Washington, DC: Smithsonian Institution Press for the National Museum of American Art, 1991.

Tucker, Anne. *Crimes and Splendors: The Desert Cantos of Richard Misrach.* Boston: Bulfinch Press in association with the Houston Museum of Fine Arts, 1996.

Turner, Frederick Jackson. "The Significance of the Frontier in American History." In *Rereading Frederick Jackson Turner: The Significance of the Frontier in American History and Other Essays*, edited by John Mack Faragher, 31–60. New York: H. Holt, 1994.

Wallach, Alan. "Thomas Cole and the Aristocracy." *Arts Magazine* 56 (November 1981): 84–106.

Warren, Louis S. *Buffalo Bill's America: William Cody and the Wild West Show.* New York: Alfred A. Knopf, 2005.

White, G. Edward. *The Eastern Establishment and the Western Experience: The West of Frederic Remington, Theodore Roosevelt, and Owen Wister.* Austin: University of Texas Press, 1989.

Wilder, Mitchell A. Preface to *Catalogue of the Collection, 1972.* Fort Worth, TX: Amon Carter Museum of Western Art, 1973.

Williams, Raymond. *The Country and the City.* New York: Oxford University Press, 1973.

Wilmerding, John, Linda Ayres, and Earl A. Powell. *An American Perspective: Nineteenth-Century Art from the Collection of Jo Ann and Julian Ganz, Jr.* Washington, DC: National Gallery of Art, 1981.

Wolf, Bryan Jay. *Romantic Re-vision: Culture and Consciousness in Nineteenth-Century American Painting and Literature.* Chicago: University of Chicago Press, 1982.